IMAGES
of Rail

ROCKFORD AREA RAILROADS

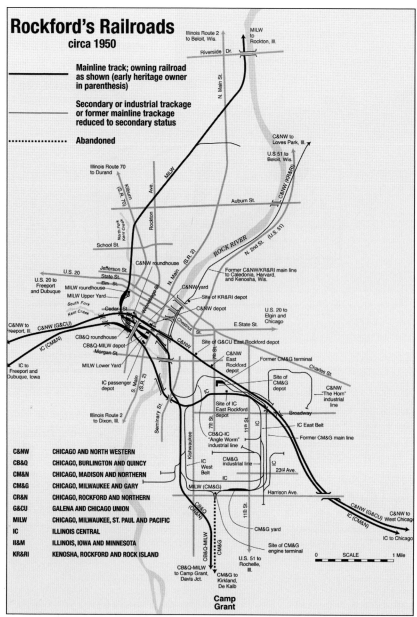

Rockford's Railroads
circa 1950

─────── Mainline track; owning railroad as shown (early heritage owner in parenthesis)

─────── Secondary or industrial trackage or former mainline trackage reduced to secondary status

·············· Abandoned

C&NW	CHICAGO AND NORTH WESTERN
CB&Q	CHICAGO, BURLINGTON AND QUINCY
CM&N	CHICAGO, MADISON AND NORTHERN
CM&G	CHICAGO, MILWAUKEE AND GARY
CR&N	CHICAGO, ROCKFORD AND NORTHERN
G&CU	GALENA AND CHICAGO UNION
MILW	CHICAGO, MILWAUKEE, ST. PAUL AND PACIFIC
IC	ILLINOIS CENTRAL
II&M	ILLINOIS, IOWA AND MINNESOTA
KR&RI	KENOSHA, ROCKFORD AND ROCK ISLAND

This map of Rockford's rail network shows the general location of lines as of the mid-20th century. Not all individual tracks are shown; rather, the map depicts key routes. The heavy black lines indicate a railroad's main line while thinner lines show secondary or industrial/switching routes. The owning railroad's initials are indicated along the various portions while a railroad's initials in parenthesis indicate the original owner or builder. (White River Junction Productions: Tom Hooper, Mike Schafer.)

ON THE COVER: Steaming into Rockford over the first rail line into town, double-headed Chicago and North Western locomotives cross the Rock River with a long, chartered train—purpose unknown—in the 1940s. Some 100 years earlier, the first train arrived in Rockford at this same locale, though on an earlier bridge. (Brian Landis collection.)

IMAGES
of Rail

ROCKFORD AREA RAILROADS

Mike Schafer with Brian Landis

ARCADIA
PUBLISHING

Published by Arcadia Publishing
Charleston, South Carolina

Printed in the United States of America

Library of Congress Control Number: 2010928650

For all general information, please contact Arcadia Publishing:
Telephone 843-853-2070
Fax 843-853-0044
E-mail sales@arcadiapublishing.com
For customer service and orders:
Toll-Free 1-888-313-2665

Visit us on the Internet at www.arcadiapublishing.com

To Mrs. Dykstra, my lovely first grade teacher at Rockford's Wight School, who in 1956 taught me to read, write, and expand my art interests (Photograph of author Mike Schafer and Marilyn Dykstra in 2009, courtesy Janet Dykstra.)

CONTENTS

ACKNOWLEDGMENTS

Doing a book of this nature is rarely a one-person task, and there are numerous friends, business associates, and members of the North Western Illinois Chapter of the National Railway Historical Society who were instrumental in helping Brian Landis and me pull this project together. First and foremost, I would like to thank Brian himself. Without his fortitude in being able to unearth Rockford railroading photographs from the 1940s and 1950s, this book would be seriously lacking. The bulk of illustration in this book can be credited to the Brian Landis collection (BLc). For years I have been aware of two Rockford-area photographers, Thomas V. Maguire and E. S. Axelson, who were pioneers in documenting the Rockford railroad scene. These men were not casual photographers; they searched out their subjects with purpose and most importantly, often made it a point to photograph a *scene* rather than just a portrait of a locomotive sitting by itself. This is why the Axelson and Maguire photographs are so important to this book, as both often included city landmarks or other familiar buildings in their photographs.

Through Brian's relentless searching over the years, he located hundreds of photographs that undoubtedly were taken by these two seemingly obscure gentlemen, both now long deceased. Sadly most were uncredited, but we are certain that the vast majority of scenes recorded between about 1940 and 1960 and now in the Landis collection can be attributed to these two pioneers in railroad photography.

In addition, I wish to thank brothers Rory and Cedric Peterson of Belvidere, Illinois, for the use of photographs taken by their father, the late Roy Peterson collection, another area pioneer railroad photographer. More thanks must go to Jerry Pyfer of Loves Park, Illinois. I moved out of Rockford in 1971 to take on an editorial job with *Trains* and *Model Railroader* magazines in Milwaukee, thus forfeiting many opportunities to continue documenting the Rockford railroad scene. Not so with Jerry. He remained in the area, working for the IC and The Milwaukee Road, camera at his side to document the changing face of railroading in Rockford throughout the 1970s and 1980s.

And finally, I wish to provide a hearty round of applause to Dick Caudle, Kevin EuDaly, Chet French, Tom Hooper, Paul Krueger, and Rockford Public Library's Jean Lythgoe and Robert Lindvall for their assistance with this project.

INTRODUCTION

Rockford was born because of water, not railroads. But if it had not been for railroads, today's Rockford might be known for being little more than a modest town on the banks of the Rock River at a location that marked an easy place for early settlers destined for Galena, in the northwest extreme of the new (1818) state, to ford the Rock River. That this ford was located about halfway between the scrappy lakefront trading post of Chicago and the bustling Galena in fact prompted the location to initially be christened Midway.

It was here in 1834 that Germanicus Kent established a sawmill on the creek that today bears his name, very close to the site of the former Illinois Central (IC) passenger depot on Rockford's South Main Street. By 1840, Midway was nearly 50 blocks large, occupied by homes, churches, general stores, saloons, and two hotels. At this time, the community had acquired an alternate name: Rockford, in reference to the shallow, "rocky ford" settlers used to cross the river.

Though limited by rudimentary roads, growth continued, and by 1852—a significant year for the community—the town was earning a reputation as an industrial center for northern Illinois. What is the special significance in 1852? First, in April of that year, Rockford was incorporated as a city; and secondly Rockford's first rail line came to life.

Today in the Chicago History Museum, a gangly looking steam locomotive named *Pioneer* stands on display—and a rare and special engine it is. Not only did it power the first train ever to depart from Chicago—today's railroad capital of North America—but it also powered the first train into Rockford.

The locomotive's pre-Chicago history is somewhat controversial. Most likely it was built in 1843 for upstate New York's Rochester and Tonawanda Railroad. In 1848, the R&T sold it to the Galena and Chicago Union Railroad (G&CU)—Chicago's first railroad—striving to build northwest to Galena, Illinois, and area lead mines.

The G&CU had been chartered on January 16, 1836, to connect Chicago with Galena, a fledgling settlement that many thought was certain to become the commercial center of the westward-expanding frontier. Construction did not begin until 1848, but on October 25 of that year, the G&CU's first official train operated, departing Chicago for Oak Park, today a Chicago suburb.

The G&CU's route out of Chicago was by way of Turner Junction (West Chicago) and today's communities of Elgin, Belvidere, and Cherry Valley. The arrival of the G&CU in Rockford in 1852 radically elevated the city's prominence and solidified its stature as one of the Midwest's leading manufacturing centers. Meanwhile, Chicago was quickly eclipsing Galena's glow, thanks to Chicago's strategic location as a port at the southern end of Lake Michigan as well as the western terminus of several new railroads from the East.

Still the G&CU continued to build beyond Rockford but never got beyond Freeport, which it reached in 1853 via Winnebago and Pecatonica. The railroad instead turned its attention to building west from Turner Junction to the Mississippi River and beyond by way of Geneva, De Kalb, Rochelle, Dixon, and Sterling. It also built north from Belvidere to Roscoe and Beloit via Caledonia.

The next railroad to arrive in Rockford eventually turned out to be the most important: the mighty Illinois Central. The IC was chartered in 1851 to build a line from Cairo, Illinois, north

7

to Dubuque, Iowa, via Freeport and Galena, and a line to Chicago via Champaign. With these lines having been mostly completed by 1854, the IC began running freight and passenger trains between Chicago and Freeport via Rockford using trackage rights on the G&CU, an arrangement that lasted until 1871 when the IC rerouted its Chicago–Freeport–East Dubuque trains over the Chicago and Iowa Railroad (C&I), bypassing Rockford. But the IC would be back.

The Kenosha, Rockford, and Rock Island Railroad (KR&RI) was next into Rockford in 1859. This railroad built from Kenosha to Rockford via Harvard and Caledonia, Illinois. It entered Rockford from the northeast—having to blast a cut through some rugged topography that today is best known as Rock Cut State Park—coming in through the burghs of Argyle and Harlem, south through the future Loves Park, and then along the Rock River to its terminal at today's Madison and Jefferson Streets.

The fourth railroad to enter Rockford was the Chicago and North Western (C&NW), but it did so the fast and easy way: by merging the G&CU out of existence on February 15, 1865, and later acquiring the KR&RI.

A decade would pass before the next new railway was built into Rockford: the Chicago, Rockford, and Northern. A subsidiary of the Chicago and Iowa Railroad, the CR&N was created to build a branch from the C&I's Aurora–Mount Morris–Forreston, Illinois, main line at Flagg Center (near Rochelle) north into Rockford. This branch opened on July 1, 1875.

That same year, 1875, yet another railroad entered the realm of Rockford when the Chicago and Pacific Railroad (C&P) opened its main line between Chicago and Byron, Illinois. This line skirted Rockford to the south by about 11 miles, crossing the C&I's new Rockford branch at a location that came to be known as Davis Junction. In 1880, the C&P was acquired by the Chicago, Milwaukee, and St. Paul (CM&StP)—or The Milwaukee Road—another booming giant of a railroad in mid-America at that time.

The CM&StP badly wanted direct access to Rockford, so the railroad proposed building its own branch from Davis Junction to Rockford parallel to the CR&N. This sparked a war between the CM&StP and the C&I. The matter was settled when the CM&StP was granted trackage rights over the C&I into Rockford in 1881. But that same year, the CM&StP also reached Rockford by building a line south into Rockford from the Beloit, Wisconsin, area.

The last steam railroad to actually construct a line into Rockford in the 19th century was the Chicago, Madison, and Northern (CM&N), which opened its Chicago–Rockford–Freeport–Madison, Wisconsin, line in 1888. The CM&N, however, was little more than a vehicle for the IC to reestablish a critical link in its system: Chicago to Freeport.

The CM&N gave IC its own, long-awaited, direct connection between Chicago and Freeport, the latter on IC's New Orleans–Cairo–Freeport–Galena–Dubuque route. With the completion of the CM&N in 1888, the IC absorbed it and thus returned to Rockford, this time on its own tracks.

The last railroad to arrive in Rockford in the 19th century was the Chicago, Burlington, and Quincy (CB&Q), when in 1899, it fully acquired the C&I and its CR&N branch into Rockford.

As the 20th century rang in on January 1, 1901, there were four railroads serving the city: IC, C&NW, CM&StP, and CB&Q. The forthcoming new century would see the U.S. railroad industry reach its zenith in the 1920s in terms of sheer traffic volume and the number of lines operated. Rockford would be a part of this scene, as it grew to be a major manufacturing center in the Midwest. Initially known best for furniture products, Rockford gained additional esteem in the realm of American manufacturing with its role in tool and die work and machinery construction.

The shipping involved in such manufacturing, both for inbound bulk raw materials and outbound finished products, was best handled by rail transport. Meanwhile, residents needed a fast, reliable means of transportation to and from Chicago and other cities, and until the 1920s, nearly 100 percent of intercity travel in the United States was done by train. One could travel and ship in all directions from Rockford.

New railroad arrivals in Rockford did not end with the 19th century though. In 1905, yet another new steam railroad, the Illinois, Iowa, and Minnesota Railroad (II&M), opened a line that stretched 118 miles from Delmar, Illinois (near the Indiana border), northeast to Rockford via

Joliet, Aurora, De Kalb, and Kirkland. Chartered in 1902 and backed with capital from Rockford interests, this railroad had ambitious plans of reaching Minnesota.

By 1908, the II&M had lost steam and was acquired by the newly formed Chicago, Milwaukee, and Gary Railroad (CM&G), which planned to make the old II&M into a Chicago bypass railroad between Gary, Indiana, and Milwaukee, Wisconsin, via Rockford. But that did not happen either. The CM&G—its slogan becoming "the Rockford Route"—squeaked along carrying only a modicum of freight and passengers. In 1930, The Milwaukee Road merged it into its transcontinental system.

There was one more new railway that would build through Rockford but of a different kind: an interurban. Almost always electrically operated, interurban railways provided frequent, local transportation between nearby towns and cities. They were popular during the first quarter of the 20th century until most were killed off by the rising popularity of automobiles in the 1920s.

Rockford's interurban system grew from its street railway network, which was born in 1881 as the Rockford Street Railway Company and initially powered by mules and horses; electric-powered streetcars or trolleys arrived in 1890. What followed then were nearly two decades of growth and expansion, with several area interurbans merged to become the Rockford and Interurban Railway (R&I). By 1910, the R&I system, including its street railway lines, comprised over 100 route miles, reaching west to Freeport, north to Beloit and Janesville, south to Camp Grant, and east to Belvidere. The R&I was enormously popular in its early years, its annual passenger count peaking at 7.5-million riders in 1910.

After World War I, the R&I weakened, owing to improved roads. In 1926, the city lines, which had been deemed solvent, were separated from the R&I and reorganized, eventually winding up as a ward of the Rockford Public Service Company (RPS). Meanwhile, the R&I went its own separate way—into receivership. Freight and express service ended in 1928, and remaining passenger service ended in 1930. Rockford's streetcar system rolled on until July 4, 1936, when the last car operated.

Although Rockford would see no more new railroads until well after World War II, it did see the rise of two new suburbs between 1900 and World War I. One has already been mentioned: Loves Park, immediately north of Rockford. It began as a tract of land between the Rock River and C&NW's Kenosha line that was owned by Malcolm Love, a Rockford industrial mogul. Both the North Western and the R&I helped foster Loves Park's development, and in 1947, the community incorporated as the City of Loves Park.

The other new suburb, if you will, was Camp Grant, immediately south of Rockford at what is today Chicago-Rockford International Airport. Camp Grant was a facility of the U.S. Army established in 1917 during World War I. Comprising some 18,000 acres, it became one of the largest army training grounds during the Great War, providing the CM&StP, CB&Q, CM&G, and the R&I with considerable traffic. Camp Grant was dismantled in 1921 once wartime activities had ceased. Camp Grant came back to life in 1940 when it was rebuilt for the oncoming World War II.

The Great Depression, whose start was signaled by the U.S. Stock Market crash of 1929, claimed the city's interurban and street railways as well as some of the services offered by the steam railroads as people traveled less and companies closed. For railroads, there were some silver linings to the Depression, among them dieselization and streamliners. But across the ocean, dire developments were leading up to an unimaginable war whose few benefits—an industrial boom and the quashing of the Nazi movement to name two—came at a frightful price.

With the U.S. entry into World War II on December 7, 1941, the country's industrial mite rose to unprecedented levels, which of course had a tremendous impact on transportation. The ability of the nation's railroads to efficiently move huge quantities of freight, wartime supplies, and equipment as well as hundreds of thousands of passengers and troops was one of the key factors to winning the war in 1945.

According to the U.S. War Department's Chicago Ordinance District during that period, Rockford was considered one of the most important cities for national defense, not only because of its industrial muscle but also because of the revived Camp Grant. A constant parade of troop

trains converged on the facility with incoming recruits and then moved them out for deployment after training. Supply trains likewise marched in and out.

The end of the war ushered in great changes throughout North America. For war-weary U.S. railroads whose locomotives, rolling stock, and infrastructure had been worked to the bone, these changes were mixed blessings. The war turned out to be the ultimate test for diesel-electric technology, introduced in the 1930s, and it was the clear-cut winner. The production of diesel-electric locomotives for both passenger and freight service exploded after 1945 as U.S. railroads rushed to do a wholesale dieselization of their systems, thereby saving millions of dollars in day-to-day operations—steam-locomotive operation being labor intensive and inefficient.

Diesels began showing up on a regular basis on Rockford's railroads as the 1940s wound down. Meanwhile, postwar euphoria continued to drive a revived and healthy economy. The bad news for railroads was that new, postwar transportation policies directed nearly all efforts toward improving highways and air transport infrastructure through public funding while railroads remained restricted by 19th century government regulations.

As a result, U.S. railroads experienced a severe decline that began in the late 1950s and extended well into the 1970s. Passenger trains were hit the hardest, but this table turned when the National Railroad Passenger Corporation was formed in 1970 to assume the operation of what few intercity passenger trains remained at the time. Better known as Amtrak, NRPC began operations on May 1, 1971. The bad news was that Rockford initially was not part of the new Amtrak system, and upon the departure of IC's Chicago-bound *Hawkeye* from Rockford 5:30 a.m. on May 1, 1971, the city found itself devoid of scheduled passenger train service for the first time in nearly 120 years.

The year 1970 also marked the start in changes ushered in by a new round of railroad mergers and whole new railroads. In March 1970, the CB&Q was merged into Burlington Northern; in 1972, the IC merged with the Gulf, Mobile, and Ohio to form Illinois Central Gulf; and in 1974, Amtrak came to Rockford with revived Chicago–Dubuque passenger service. Things quieted down until 1985 when The Milwaukee Road was purchased by the Soo Line Railroad (SOO), bringing that railroad into Rockford. The same year, the unthinkable happened when ICG sold its Chicago–Iowa main line to the new Chicago, Central and Pacific Railroad. But in 1996, the "new" Illinois Central (having dropped the "Gulf" from its 1972 merger name) bought out the CC&P, and the IC returned to Rockford for the third time.

Meanwhile, the C&NW was merged into the Union Pacific (UP) in 1995, and the SOO had been acquired by the Canadian Pacific (CP), which brought the first Canadian-owned railroad into Davis Junction and Rockford, on former Milwaukee Road tracks. Then CP sold these lines to the I&M Rail Link in 1997, which in turn sold them to the new Iowa, Chicago, and Eastern in 2002. In 2008, the IC&E was merged with the Dakota, Minnesota, and Eastern, which in turn was brought into the fold of CP; thus, the CP has returned to Rockford for a second time.

There is more though. In 1996, Burlington Northern merged with the famous Atchison, Topeka, and Santa Fe, forming today's BNSF Railway; the BNSF wound up spinning off its old CB&Q Rockford Branch to the Illinois Railnet (now Illinois Railway) (IR) in 1997. In 1998, Canadian National (CN) gained control of the IC, bringing a second Canadian-owned railroad into Rockford.

As this book went to press in 2010, CN, CP, UP, and IR served Rockford, with Amtrak scheduled to return by 2014. History keeps happening.

One

THE RISE OF
RAILROADS IN ROCKFORD

1852–1900

Although not an unusual locomotive unto itself—there were many similar to it during the early railroad-building years of the 1830s—the 4-2-0 steam locomotive named *Pioneer* depicted on this collector's plate, manufactured in England, reached twofold celebrity status. It was the locomotive that pulled the first train in Chicago in 1848, and it also led the first train into Rockford, Illinois, in 1852. (BLc.)

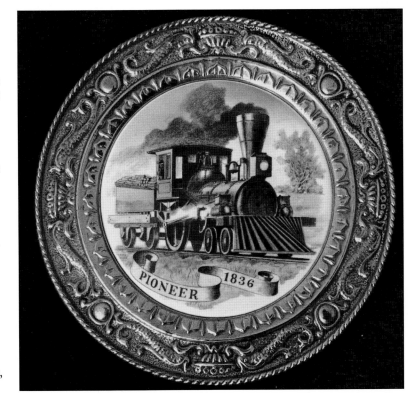

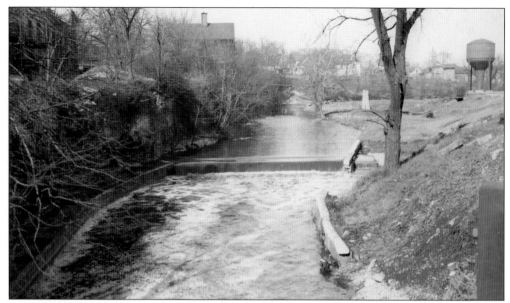

This may be where it all started. This view, taken from the Illinois Central bridge over Kent Creek at South Main around 1950, looks westward. The dam is speculated to be the site of Germanicus Kent's sawmill, the genesis of Rockford. The roof at top left center is that of Tinker Swiss Cottage, and the water tank at upper right is for watering IC steam locomotives. (BLc.)

On May 2, 1948, Rockfordians gather around two display cars in the Chicago and North Western freight yard. The gangly locomotive is none other than the *Pioneer*, which pulled the first train into Rockford in 1852. The C&NW toured its system with these display cars to commemorate another event: the centennial of the first train (also pulled by the *Pioneer*) to depart Chicago in 1848. (Roy Peterson collection.)

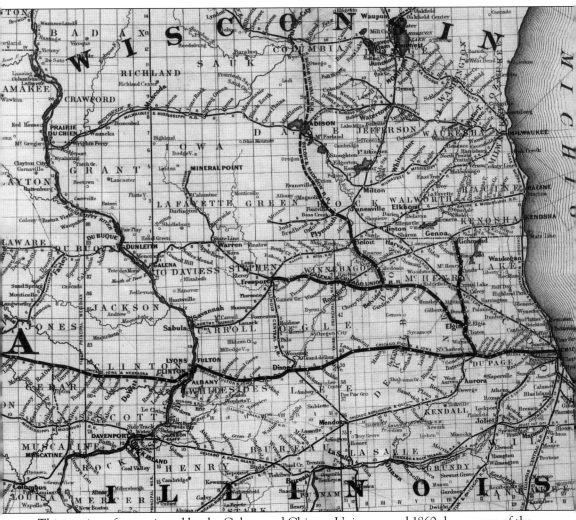

This portion of a map issued by the Galena and Chicago Union around 1860 shows some of the extent of its expansion after having decided not to build beyond Freeport, instead focusing on reaching west via Rochelle, Illinois, and Clinton, Iowa. Of particular note is that the GC&U built a branch northwest from Belvidere to Beloit, Wisconsin, skirting Rockford at Roscoe. Also note the Kenosha, Rockford, and Rock Island. (BLc.)

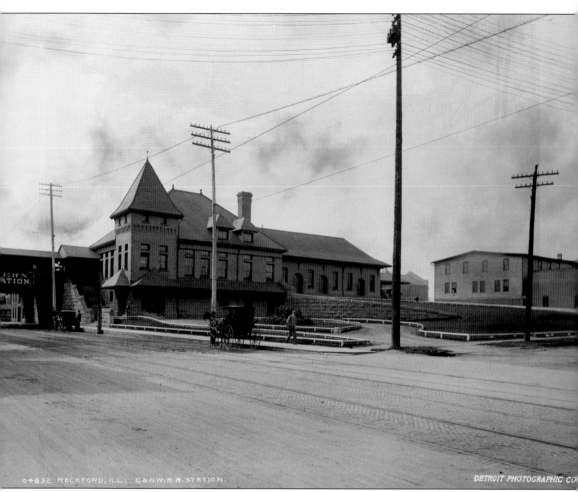

Chicago and North Western built this handsome brick-and-stone depot at South Main and Cedar Streets in 1893 to serve passengers riding Rockford's pioneer railroad line. Almost immediately beyond the overpass was Rockford Union Station, used by the Chicago, Milwaukee, and St. Paul (The Milwaukee Road) and Chicago, Burlington, and Quincy. (Courtesy Library of Congress, negative 4a042267u, Prints and Photographs Division, Detroit Publishing Company Collection.)

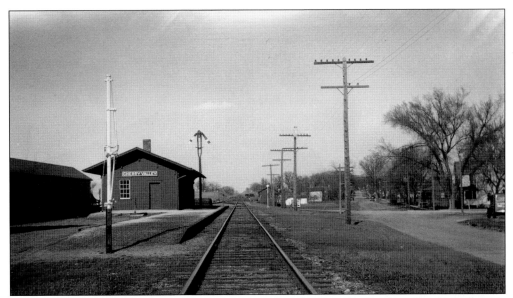

For the G&CU building into Rockford, it was pretty much a straight shot west from Belvidere via Cherry Valley. Settled in the late 1830s, Cherry Valley was incorporated in 1857, five years after the G&CU opened. The town's tidy frame C&NW depot is shown in 1950. As this book went to press in 2010, plans were under way to restore passenger-train service to this route between Chicago and Rockford. (Roy Peterson collection.)

GC&U's Belvidere–Beloit line skirted Rockford at Roscoe, which today is almost a Rockford suburb. This photograph of an eastbound passenger train was probably taken to show off the impressive new stone bridge over Kinnikinnick Creek. The bridge remains, today carrying the Stone Bridge Trail recreational path. (BLc.)

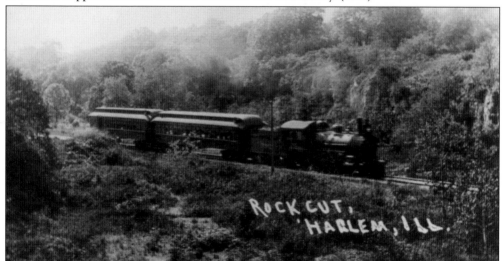

The Kenosha, Rockford, and Rock Island Railroad had its sights set on linking Kenosha, Wisconsin, with the Mississippi River, forming a through route for freight moving between Great Lakes ports and the Gulf of Mexico. The KR&RI was the third railroad to reach Rockford, in 1859, and this is where it stopped. Stock for the new endeavor was sold locally. (BLc.)

The KR&RI aimed its way into Rockford by way of Caledonia, Argyle, and Harlem. Overall the grading and construction was routine, except for a large, solid limestone hill about 8 miles out of Rockford. The railroad blasted a cut through the hill in 1858. This C&NW passenger train is at the cut around 1910. Today this part of the route lies under the waters of Pierce Lake in Rock Cut State Park. (BLc.)

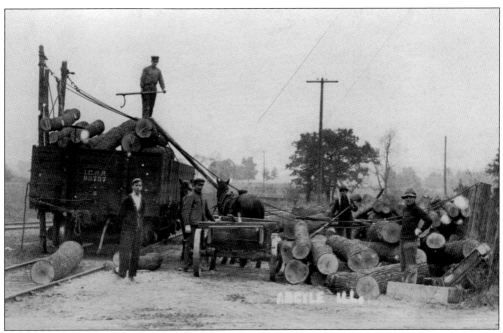

When this photograph was taken early in the 20th century at little Argyle, Illinois, the town was but a lonely outpost 10 miles out of Rockford on Chicago and North Western's former KR&RI line. Pictured here, workers take a break from loading fresh-cut logs into an Illinois Central gondola. At length, a C&NW train will pick up the gondola and forward it to a mill, probably in Rockford. (BLc.)

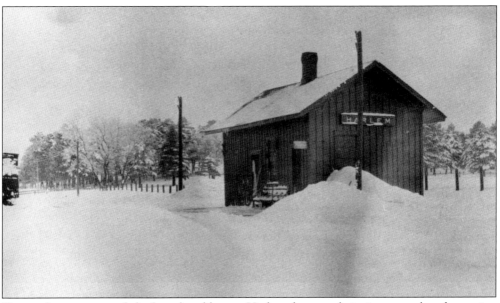

Heaps of snow surround the board-and-batten Harlem depot early in its career, but the station agent has diligently swept the platform for arriving passengers. The view looks north-northeast from today's Harlem Road just east of Forest Hills Road. Harlem wound up being incorporated into nearby Loves Park. (BLc.)

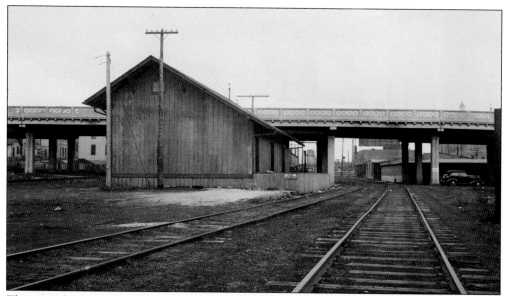

This view from April 3, 1938, looks southwesterly along the Chicago and North Western's old KR&RI line—by this time known as the "KD (for Kenosha Division) Line" at the Jefferson Street Bridge. The wood-framed freight house is none other than the erstwhile KR&RI depot, having been remodeled into a freight house for the C&NW. This is where the line originally terminated. (Roy Peterson collection.)

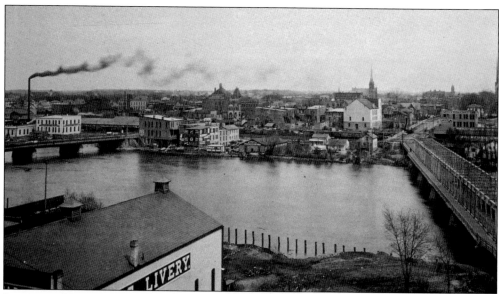

In a view that looks east across the Rock River from downtown Rockford in the late 1800s, strings of boxcars denote a portion of C&NW's old KR&RI freight yard. At left is the State Street Bridge and at right the Chestnut Street Bridge. Although the yard was long ago removed, the main track is still in place and serves as a spur to Loves Park. (Local History Department, Rockford Public Library.)

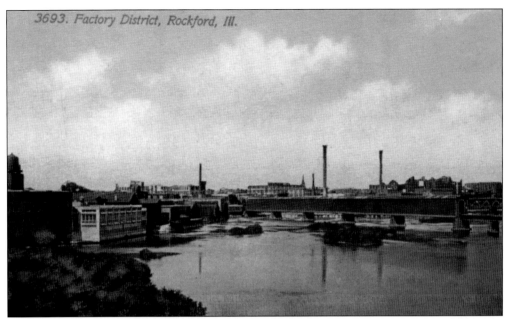

3693. Factory District, Rockford, Ill.

This postcard view from about 1910 looking north at Rockford's "Factory District" provides a view of Chicago, Burlington, and Quincy's first bridge—a rare covered bridge, no less—over the Rock River, just below the Fordam Dam. The iron bridge beyond is that of C&NW. (BLc.)

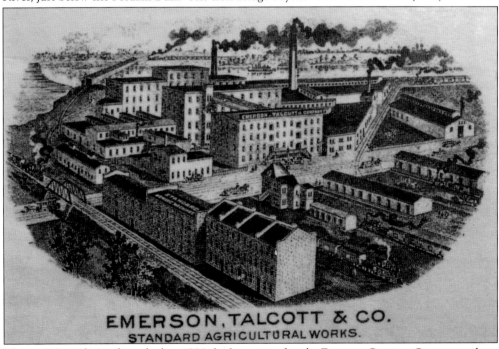

EMERSON, TALCOTT & CO.
STANDARD AGRICULTURAL WORKS.

This artist's rendering from the late 1800s looks eastward at the Emerson Carriage Company—later Emerson, Talcott, and Company—complex and Rockford Union Station (the house-like structure at center along South Main Street), which was also Emerson's office. The Chicago, Burlington, and Quincy's covered bridge over the Rock River is at upper left; the C&NW's main line is at lower left, but its South Main Street depot has not been built yet. (BLc.)

M & ST.P.& BURLINGTON RY. DEPOT
ROCKFORD, ILL.

The CM&StP and the CB&Q shared this brick Victorian depot at 609 South Main Street; the building also served as the main office of Emerson, Talcott, and Company. The railroads' ticketing offices were in the lower level. This view from about 1910 looks west shortly after the arrival of a Burlington train from Chicago. The railroads referred to this facility as Rockford Union Station, but as grandiose as that title may have sounded, it was actually the smallest of the three main downtown steam railroad depots in Rockford. (BLc.)

PASSENGER TRAINS
— AT —
ROCKFORD, ILL.

In Effect October 22, 1899. Subject to Change.

DEPART FOR	PRINCIPAL POINTS.	ARRIVE FROM
* 7.10 A.M. † 8.05 A.M. † 10.45 A.M. * 3.00 P.M.	CHICAGO, ELGIN, Etc. a. Dining Cars on trains to and from Chicago.	† 11.35 A.M. † 4.45 P.M. † 6.20 P.M. * 8.30 P.M a § 11.28 A.M.
† 8.10 A.M. † 11.35 A.M. † 2.35 P.M. ↓ 4.50 P.M.	MILWAUKEE.	† 10.45 A.M. † 1.15 P.M. † 4.15 P.M. † 6.55 P.M.
† 8.10 A.M. † 11.35 A.M. † 2.35 P.M. † 4.50 P.M. † 6.20 P.M. * 8.35 P.M c § 11.28 A.M.	BELOIT and JANESVILLE. c. Do not go past Beloit.	* 7.10 A.M. c † 8.05 A.M. † 10.45 A.M. † 1.15 P.M. † 4.15 P.M. † 6.55 P.M. § 3.00 P.M.
† 8.10 A.M. † 4.50 P.M.	BRODHEAD, MONROE, DARLINGTON, MINERAL POINT, Etc.	† 10.45 A.M. † 6.55 P.M.
† 11.35 A.M. 4.50 P.M.	RACINE, DELAVAN, SPRING-FIELD AND BURLINGTON.	† 1.15 P.M. † 4.15 P.M.
† 8.10 A.M. † 2.35 P.M. † 4.50 P.M.	MADISON.	† 10.45 A.M. † 1.15 P.M. † 6.55 P.M.
† 8.10 A.M. † 2.35 P.M.	LA CROSSE, WINONA, ST. PAUL AND MINNEAPOLIS. Via Madison.	† 10.45 A.M.
‡ 6.55 P.M.	ST. PAUL AND MINNEAPO-LIS. Via Davis Jct. and Savanna.	¶ 8.00 A.M.
‡† 2.35 P.M. ‡ 6.55 P.M.	NORTHERN IOWA, MINNESOTA and DAKOTA.	¶ 8.00 A.M. † 1.15 P.M.
† 3.00 P.M. ‡ 6.55 P.M.	DUBUQUE AND CEDAR RAPIDS.	¶ 8.00 A.M. † 11.35 A.M.
† 3.00 P.M. ‡ 6.55 P.M.	STILLMAN VALLEY, BYRON, LEAF RIVER, LANARK, MT. CARROLL AND SAVANNA.	¶ 8.00 A.M. † 11.35 A.M.
† 3.00 P.M.	ROCK ISLAND.	† 11.35 A.M.
† 3.00 P.M.	KANSAS CITY, OTTUMWA, AND THE SOUTHWEST.	¶† 8.00 A.M. † 11.35 A.M.
* 6.55 P.M.	OMAHA, COUNCIL BLUFFS, SIOUX CITY, Etc.	* 8.00 A.M.
† 8.10 A.M. † 2.35 P.M.	WAUKESHA, WHITEWATER Etc.	† 10.45 A.M. † 6.55 P.M.

* Daily. † Daily Except Sunday. ‡ Daily Except Saturday. ¶ Daily Except Monday.
§ Sundays only.

For further information, Tickets, Time Tables, etc., apply to

J. A. COTTON,
Passenger Agent.

A. G. EVERETT,
Ticket Agent.

This Milwaukee Road time card tailored to the Rockford market illustrates just how comprehensive rail passenger service was in Rockford at the close of the 19th century on just the CM&StP. Direct service between Rockford and Chicago via Davis Junction numbered four trains each way on weekdays, with some offering dining-car service. In reality, most destinations shown required a change of trains, either at Davis Junction, Beloit, Janesville, or Madison. (Mike Schafer collection.)

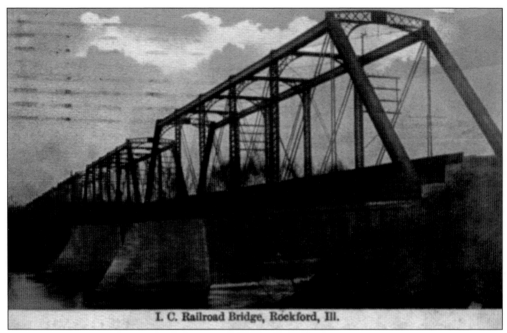

I. C. Railroad Bridge, Rockford, Ill.

Illinois Central's first Rock River bridge, built by subsidiary Chicago, Madison, and Northern around 1888 at Rockford, was this through-truss structure with five spans. This view is from the west bank of the river. This bridge and the stone piers were replaced by a heavy-duty steel deck girder bridge with concrete piers during the World War I period. It still stands. (BLc.)

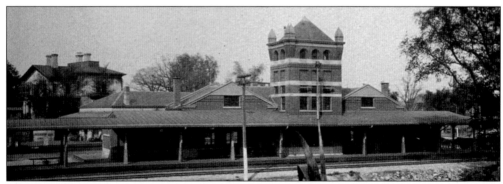

The handsome Illinois Central depot on South Main Street is shown around 1890 in a view taken from across Kent Creek near the grounds of Tinker Swiss Cottage. In the background is the mansion of the late John Manny, who in the early 1850s developed the New Manny Reaper and Mower, which was manufactured by Emerson and Company, just down the street near the CM&StP station. (Rockford Public Library.)

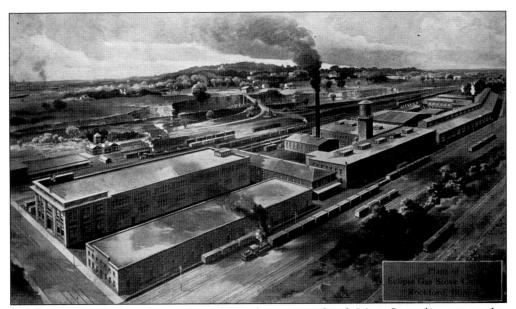

The Eclipse Gas Stove Company complex is shown at its South Main Street location in this artist's rendering from the late 1880s. Also shown is South Main Street (lower left), Tinker Swiss Cottage (upper center) on the bluffs of Kent Creek, and the new IC passenger depot and freight house (center left). The artist has taken considerable license, showing Tinker Swiss Cottage considerably farther west of the IC depot than it really is. (Rockford Public Library.)

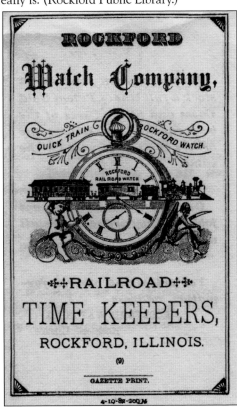

Rockford had a number of direct ties to the railroad industry over the years, and one of the earliest was the Rockford Watch Company, noted for its railroad watches. Later Woodward Governor would manufacture components for diesel locomotive builders while Rockford Screw Products provided parts for Amtrak's new bilevel Superliner cars in the 1970s and 1980s. (BLc.)

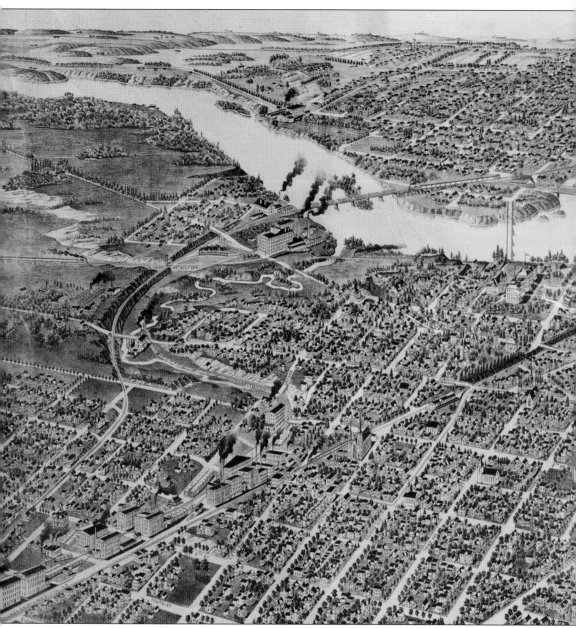

This incredibly detailed, hand-drawn perspective map dating from 1891 shows the heart of railroading in Rockford at that time. The view looks southwest. At upper left is IC's circuitous path through the city, while the C&NW's former G&CU main makes a straight shot from the

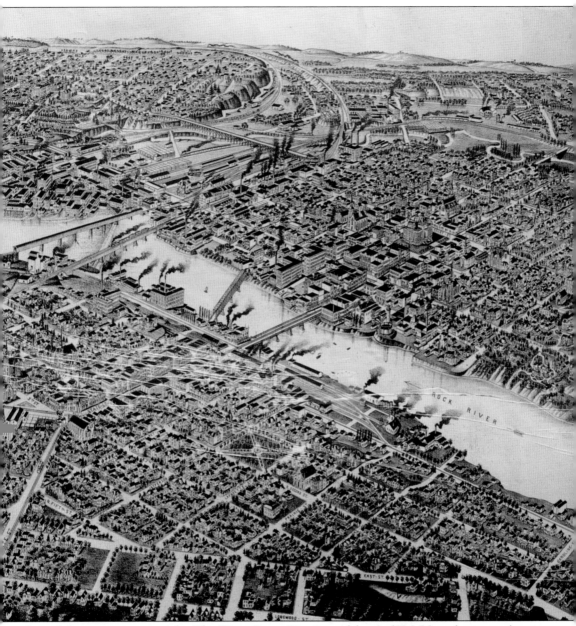

lower left corner to upper right. The Water Power District and former KR&RI tracks are on the west side of the river at center right. (BLc.)

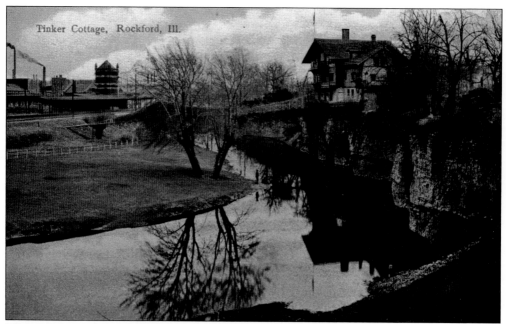

The proximity of the 1880s IC depot and famous Tinker Swiss Cottage, along Kent Creek, is clearly illustrated in this postcard view that looks eastward. Arguably still Rockford's best-known historical site, Tinker Swiss Cottage was built in 1865 by Robert Tinker, inspired by similar dwellings he had seen in Europe. For a time, the open area on the north bank was known as Illinois Central Park and featured gardens. (BLc.)

Not all of Rockford's railroad depots were on the west side. IC and C&NW both had East Rockford depots. C&NW's restored East Rockford depot (at right) still stands at Seventh Street and Sixth Avenue. At center in this 2001 view is the former C&NW east-side freight house, built in 1910. Photographs of IC's East Rockford Station, which stood between Ninth and Tenth streets, have yet to surface. (Photograph by Mike Schafer.)

Two

ROCKFORD'S RAILROADS COME OF AGE
1901–1940

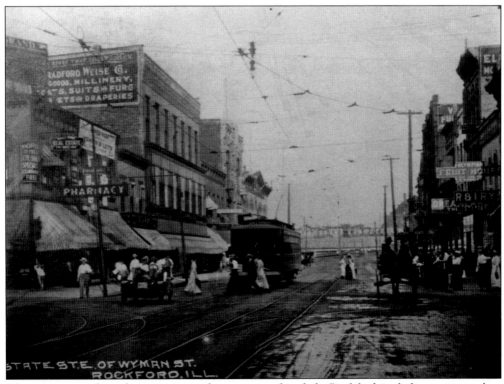

The new century brought prosperity and more new railroads for Rockford, including an interurban system. It also brought a world war, the Roaring Twenties, and the Great Depression. Early in the century, the downtown intersection of State and Wyman Streets was a popular transfer point for streetcars and interurbans; note the "R & I RY" sign at far right. The three-story brick building (left) is Weise's department store, a downtown landmark into the 1960s. (BLc.)

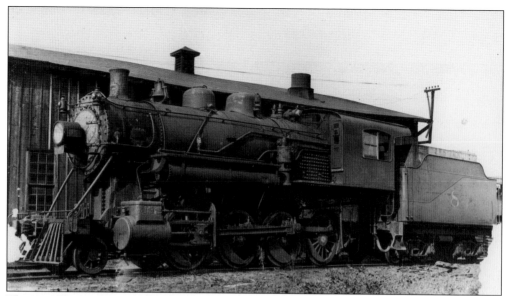

The new Illinois, Iowa, and Minnesota Railroad arrived in Rockford in 1905 but in 1908 was reorganized as the Chicago, Milwaukee, and Gary; photographs of both roads are exceptionally rare. In April 1919, CM&G 2-8-0 Prairie-type locomotive No. 8, built in 1905 originally for the Detroit, Toledo, and Ironton, is at either the road's Seventh Street terminal or its Harrison Avenue engine-servicing facility. (Paul Krueger collection.)

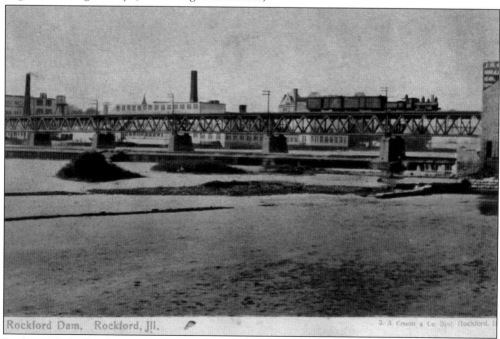

Rockford Dam, Rockford, Jll.

In this early-20th-century postcard, a Chicago and North Western switch job heads east across the Rock River with cars destined for east-side customers. The vantage point of this photograph, which was probably the Burlington's river bridge, best shows the Rockford Dam, later known as Fordam Dam. Sluiceways on either side of the river around the dam provided waterpower for riverside mills and manufacturing plants. (BLc.)

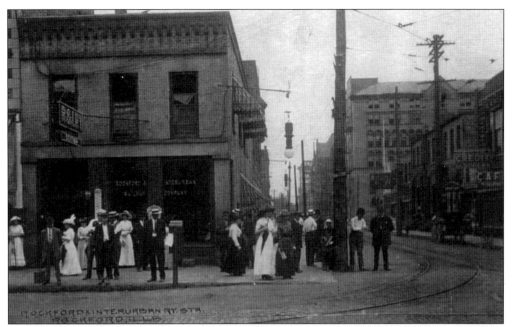

Passengers are milling about the Rockford and Interurban's main depot in downtown Rockford. The building stood on the corner of State and Wyman Streets; this view looks south along Wyman Street with State Street in the foreground. The building outlived the R&I until after World War I when the 1931 widening of Wyman Street resulted in its being razed. (BLc.)

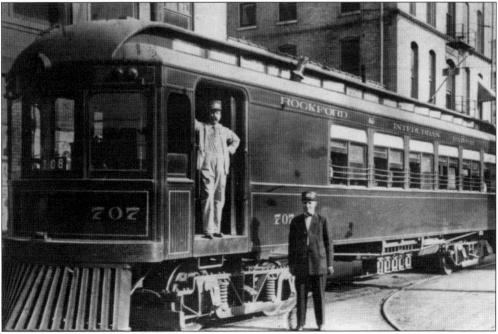

An R&I conductor and his motorman pose with R&I car No. 707 on Wyman Street at the downtown Rockford Station. This handsome wooden car, replete with gold pin striping, was built by Niles (Ohio) Car Company in 1902 for the Rockford, Beloit, and Janesville Railway, which was merged into the R&I. (BLc.)

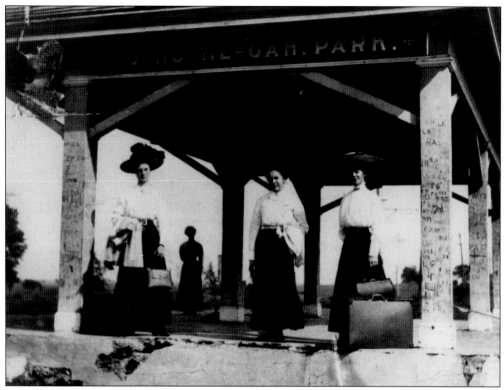

Three lovely ladies await an R&I interurban to take them home after an extended stay at Ho-no-ne-gah Park. It was the Edwardian period (pre–World War I, 20th century) when dressing up was still proper etiquette while traveling. (BLc.)

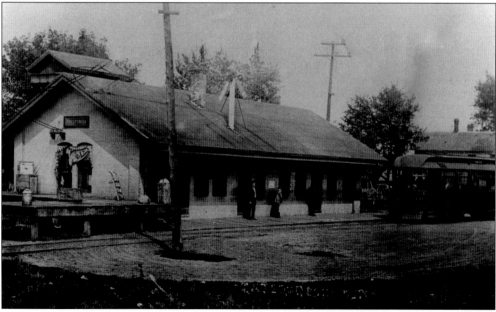

Pecatonica residents could avail themselves the services of the R&I at this stately brick depot—indeed a large station for a modest interurban line serving a modest-size town. (BLc.)

Oscar Johnson proudly displays his dapper Rockford and Interurban uniform in 1905. "R & I Ry. Co." is embroidered on his lapels, while R&I brass buttons adorn his jacket and a brass R&I conductor's badge his hat. "Uncle Oscar" passed this photograph down to his nephew, Roy Peterson collection, who took a number of the photographs appearing in this book. (Roy Peterson collection.)

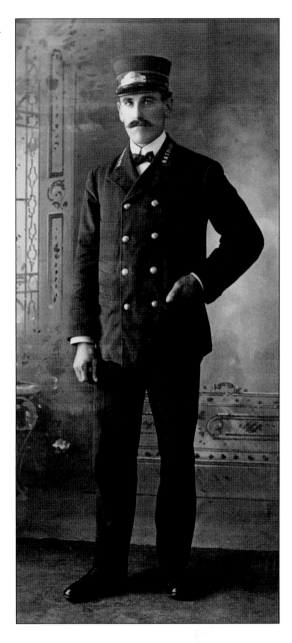

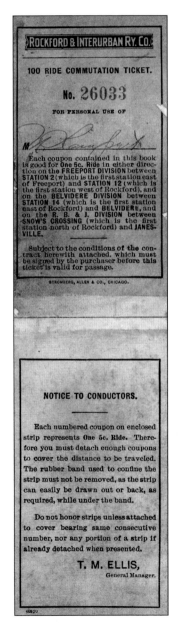

ROCKFORD & INTERURBAN RY. CO.

100 RIDE COMMUTATION TICKET.

No. 26033

FOR PERSONAL USE OF

M. _____

Each coupon contained in this book is good for One 5c. Ride in either direction on the FREEPORT DIVISION between STATION 2 (which is the first station east of Freeport) and STATION 12 (which is the first station west of Rockford), and on the BELVIDERE DIVISION between STATION 14 (which is the first station east of Rockford) and BELVIDERE, and on the R. B. & J. DIVISION between SNOW'S CROSSING (which is the first station north of Rockford) and JANESVILLE.

Subject to the conditions of the contract herewith attached, which must be signed by the purchaser before this ticket is valid for passage.

STROMBERG, ALLEN & CO., CHICAGO.

NOTICE TO CONDUCTORS.

Each numbered coupon on enclosed strip represents One 5c. Ride. Therefore you must detach enough coupons to cover the distance to be traveled. The rubber band used to confine the strip must not be removed, as the strip can easily be drawn out or back, as required, while under the band.

Do not honor strips unless attached to cover bearing same consecutive number, nor any portion of a strip if already detached when presented.

T. M. ELLIS,
General Manager.

The R&I served as a commuter system for people who used it on a daily basis to get to work and back; for example, the R&I would have been handy for people living in Belvidere, Pecatonica, or Loves Park who worked in downtown Rockford. For such commuters, the R&I offered a special-price, 100-ride commutation ticket, which commuter railroads still offer. (Roy Peterson collection.)

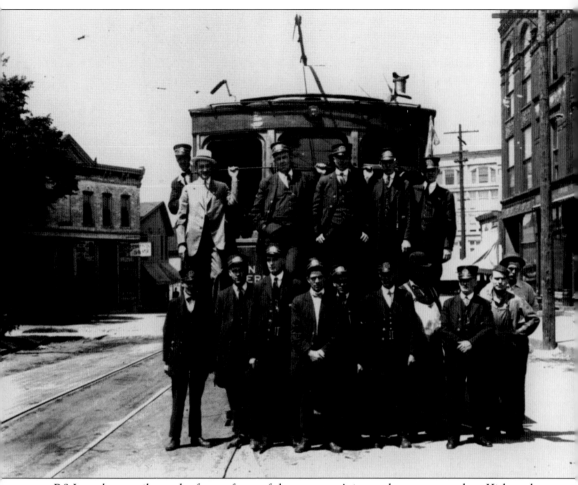

R&I employees pile on the front of one of the company's interurban cars posed on Kishwaukee Street near First Avenue. Whether this was a special occasion is unknown, but the photograph was likely taken in the 1920s. At right in the distance is the looming facade of Hess Brothers department store; this book's author, Mike Schafer, worked in the building at left (which still stands) in the late 1960s, when it was Mid-West Studio. (BLc.)

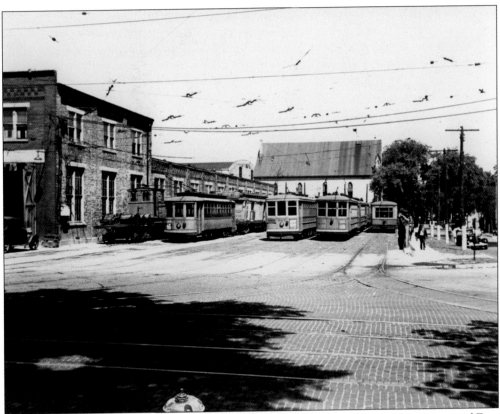

The main carbarn for Rockford's streetcars and interurbans stood at Kishwaukee Street and First Avenue. This view looks east from Kishwaukee Street (foreground); the Ohave Shalom synagogue is at center background. This photograph was probably taken shortly before the 1936 demise of Rockford's streetcar system. After that and into the 1960s, the facility was used by city buses. The building at left is still in use although heavily disguised by shrouding. (BLc.)

The main shop complex for Rockford Public Service Corporation and the R&I was located on the east side of North Second Street in Loves Park. Known as North Shop, it is shown on April 3, 1936. The main structure at left remains—entombed by the newer buildings of the Woodward Governor complex. (Roy Peterson collection.)

Even 100 years ago, advertising was seemingly everywhere. This cover of this R&I timetable from around 1910 features an advertisement from local clothier E&W Clothing House in the 100 block of South Main Street, Rockford. (BLc.)

Inside the R&I timetable was a complete set of times for the passenger trains of all railroads serving Rockford at the time. Around 1910, R&I had almost hourly service to Belvidere, Beloit, Janesville, and Freeport. Similarly the steam railroads also offered comprehensive services out of Rockford in all directions. (BLc.)

ROCKFORD & INTERURBAN TIME TABLE.

To Belvidere, Elgin and Chicago.
First Car Leaves Rockford 6:00 a. m.

Next 7:30 a. m.	Next 4:40 p. m.
Next 8:00 a. m.	Next 5:45 p. m.
Next 8:50 a. m.	Next 6:55 p. m.
Next 10:40 a.m.	Next 7:45 p. m.
Next 11:40 a. m.	Next 9:20 p. m.
12:40 for Belvidere, Saturday only.	
Next 1:40 p. m.	Next 11:15 p. m.
Next 3:40 p. m.	

Rockford, Beloit and Janesville.
First Car Leaves Rockford 5:40 a. m.
Next 7:00 a. m.
And every hour after 7:00 a. m. until 10:00 p. m. for Janesville, and 11:15 p. m. for Beloit.

Rockford to Freeport.
First Car Leaves Rockford 5:00 a. m.

Next 5:30 a. m.	Next 1:50 p. m.
Next 6:50 a. m.	Next 2:40 p. m.
Next 7:50 a. m.	Next 4:50 p. m.
Next 8:50 a. m.	Next 6:05 p. m.
Next 9:50 a. m.	Next 7:50 p. m.
Next 11:50 a. m.	Next 9:50 p. m.
Next 12:50 p. m.	Next 11:15 p. m.

ILLINOIS CENTRAL RY.
Leave Rockford for Chicago.

6:00 a. m.	2:58 p. m.
7:05 a. m.	7:00 p. m.
10:26 a. m.	9:00 p. m.

1:30 p. m. special, on Saturday only.
For Points in Iowa and Points South.
Leave Rockford.
10:40 a. m.
12:00 noon for Freeport only. Connection for all points south.
6:25 p. m. To Dubuque only.
7:15 p. m. Fast train for Omaha.
7:15 p. m. For Minneapolis and St. Paul.

CHICAGO NORTHWESTERN RY.
Leave Rockford for Chicago.
*Daily except Sunday.
7:05 a. m.
* 9:50 a. m.
* 2:00 p. m.
5:10 p. m.
Leave Rockford for Freeport.
11:00 a. m.
* 2:30 p. m. Makes connections on D. C. south.
* 7:25 p. m.
10:00 p. m.
Wisconsin Division, Points North Via. Caledonia.
* 9:47 a. m.
* 2:15 p. m.
* 5:10 p. m.
7:00 a. m. For Harvard and south.

CHICAGO, MILWAUKEE & ST. PAUL RAILWAY.
Leave for Chicago Via. Davis Junction.
5:55 a. m.
10:40 a. m.
2:45 p. m.
7:15 p. m. Makes connection for Omaha, Kansas City, Davenport, Rock Island, etc.
Points North—Janesville, Milwaukee and St. Paul and Points North.
* 8:30 a. m. To Madison on Sunday.
* 3:30 p. m.
* 8:50 p. m. to Beloit only.
For Ladd, Spring Valley and Mendota.
Leave Rockford * 10:40 a. m.

BURLINGTON ROUTE.
Leave Rockford for Chicago Via. Rochelle.
* 6:30 a. m.
3:45 p. m.

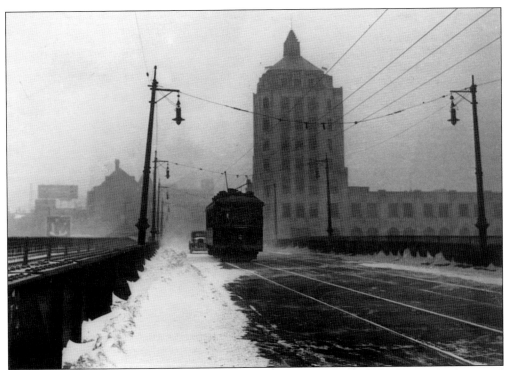

A dreary winter day like this in downtown Rockford early in the 1930s was certainly a good time to take the trolley to work rather than drive. One of Rockford Public Service's cars scoots across the East State Street river bridge with the new Rockford Newspapers building serving as a dramatic backdrop. (BLc.)

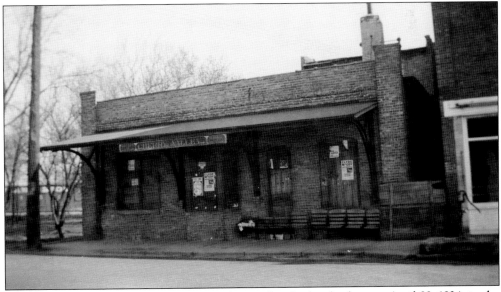

The R&I's Cherry Valley depot is shown, shuttered and a bit derelict, on April 29, 1934, in the twilight years of the R&I. Amazingly this building still stands in downtown Cherry Valley and overall looks the same, right down to the canopy. It has been handsomely restored and is used by the Cherry Valley Fire Department. (Roy Peterson collection.)

Opened in 1917 just south of Rockford to train soldiers for the Great War (World War I), Camp Grant was its own city with its own railroad stations—and even its own postcards. (Curt Teich and Company; BLc.)

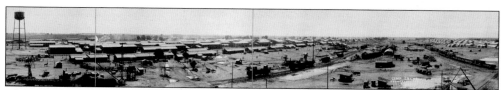

This composite photograph shows a panorama of a portion of Camp Grant in September 1917. The main lines of the Burlington; Milwaukee Road; Chicago, Milwaukee, and Gary; and Rockford and Interurban all skirted the east side of the facility, but as evident here, spur tracks were laid into the camp to for incoming supplies and troops. (Courtesy Library of Congress, negative 6a31294u, Prints and Photographs Division, Rockford Illustrating Company Collection.)

Effective July 29, 1919
Subject to change

ROCKFORD—CAMP GRANT—ELGIN—CHICAGO

TO CHICAGO	32 Daily Except Sunday	34 Daily Except Sunday	8 Daily	38 Daily Except Sunday	26 Daily	40 Sunday Only	50 Daily	6 Daily	36 Daily	30 Daily Except Sunday	24 Daily	42 Sat. Only	12 Daily	TO CHICAGO
	AM	AM	AM	AM	AM	AM	AM	AM	AM	AM	PM	PM	PM	
Lv Rockford						5.55		5.55		10.40	2.45		6.50	LvRockford
* Camp Grant						6.05		6.05		10.50	2.55		7.00	*Camp Grant
* Davis Junction			5.55		6.23		6.50			11.11	3.10		8.20	*Davis Junction
* Elgin	c 6.10	c 6.25	7.05	c 7.20	7.30	7.35	7.45	8.00	9.00	12.30	4.30	6.15	9.30	*Elgin
* Spaulding		6.32				7.41	7.53			12.37	4.43	6.22		*Spaulding
* Bartlett	6.22	6.38				7.45	8.10			12.41	4.48	6.26	g 9.39	*Bartlett
* Ontarioville	6.26	6.42				f 7.48	8.20			12.44	4.52	6.29		*Ontarioville
* Roselle	6.33	6.50				7.55	8.34			12.50	5.01	6.36	b 9.46	*Roselle
* Meacham	6.37	f 6.54				f 7.59	8.42			f 12.52	5.04	6.39		*Meacham
* Itasca	6.41	6.59				8.03	8.50			12.57	5.09	6.43		*Itasca
* Wooddale	6.45	f 7.03				f 8.06	8.58			f 1.00	f 5.13	6.46		*Wooddale
* Bensenville	6.49	7.07				8.11	9.06			1.04	5.18	6.49		*Bensenville
* Mannheim	6.55	7.14				8.18	9.13			1.09	5.24	6.55		*Mannheim
* Franklin Park	6.57	7.17				8.19	9.17			1.11	5.26	6.57		*Franklin Park
* River Grove	7.01	7.20				8.22				f 1.15	5.30	7.01		*River Grove
* Mont Clare	7.05	7.22				8.24	9.29			1.19	5.34	7.05		*Mont Clare
* Galewood	7.07	f 7.24				8.26				y 1.21		f 7.07		*Galewood
* Hanson Park										y 1.23				*Hanson Park
* Cragin	7.11	7.28				8.28	9.37			y 1.25		7.11		*Cragin
* Hermosa	7.15	7.32				8.31	9.52		9.47	y 1.29	5.43	7.14		*Hermosa
Ar Western Avenue	7.24	7.43	8.03	8.12	8.19	8.42	10.00	8.52	9.55	1.40	5.54	7.24	10.19	Ar ..Western Avenue
Ar Union Pass'r Sta.	7.35	7.55	8.15	8.23	6.30	8.55	10.15	9.05	10.10	1.50	6.05	7.35	10.30	Ar ..Union Pass'r Sta
See Note for Holiday Service	AM	AM	AM	AM	AM	AM	AM	AM	AM	PM	PM	PM	PM	

c Also stops at National Street, Elgin, to pick up passengers
f Flag stop. g Stops Sundays to let off passengers from Elgin.
h Regular stop Sundays only to discharge and pick up passengers.

y Stops to let off passengers from points west of Elgin.
See Note on other side for Holiday Service.

PASSENGER
Train Service

Chicago
Elgin
Camp Grant
and
Rockford

Effective July 29, 1919

United States Railroad Administration
W. D. HINES, Director General of Railroads

Chicago, Milwaukee & St. Paul Railroad
GEO. B. HAYNES, General Passenger Agent, CHICAGO

Form 7-No 4. 7-29-19

This public timetable issued by the Chicago, Milwaukee, and St. Paul through the U.S. Railroad Administration, which took over the operations of most U.S. railroads during World War I, provided schedules for trains between Camp Grant, Davis Junction, and Chicago. (BLc.)

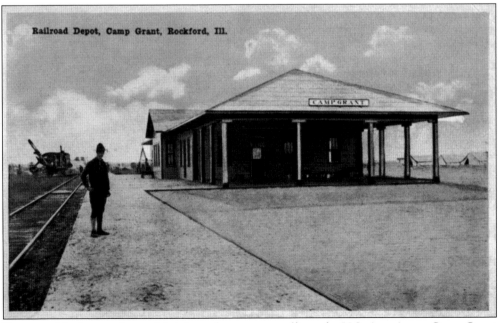

Because of the huge volume of freight and passenger traffic at the U.S. Army's new Camp Grant training facility, the CB&Q, CM&StP, CM&G, and R&I all built depots nearby. Though not specifically identified as such in this postcard view, this depot was built by the Burlington in 1917. (BLc.)

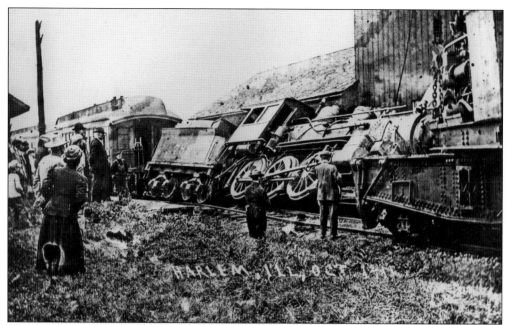

Passengers heading from Rockford to Caledonia and Kenosha on the Chicago and North Western on October 1, 1911, did not get very far before the train's locomotive derailed at the Harlem Station, supposedly owing to sand on the tracks but more likely from a washout. A steam crane (right) has been dispatched from Belvidere to help upright the locomotive. The incident seemed to mirror the line's bleak future. (BLc.)

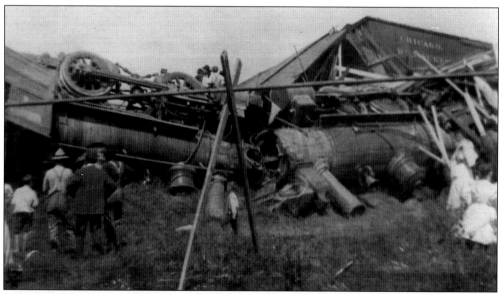

Early railroading was a dangerous profession as evidenced by not only the previous photograph but also this scene of a head-on collision between two Chicago, Milwaukee, and St. Paul trains near Auburn Street on August 20, 1908. Although the details of this accident were unknown to the authors, a head-on almost certainly indicates that one of the engine crews misread their train orders received at Rockford or Rockton. (BLc.)

Argyle, Illinois, looks serene in this early-20th-century scene. The view looks southeast at the business district, with the C&NW running east and west through the picture. The depot is the dark-colored structure to the right of the gondola car parked on the "team track" for loading. Nearly all the buildings have since vanished with the exception of that in the center with the enclosed stairway. (BLc.)

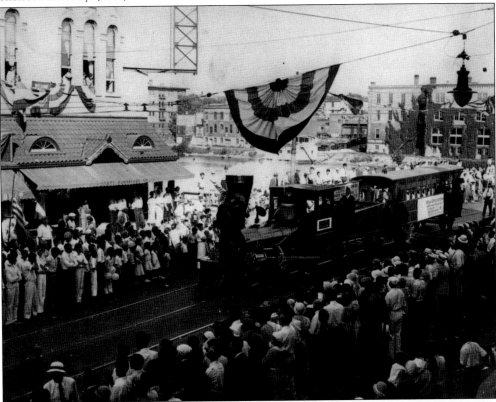

State Street at the Rock River bridge is jammed with Rockfordians enjoying a parade, possibly for Independence Day. The C&NW has sent its replica Pioneer parade "locomotive"—a tractor in disguise—to star in the parade. With streetcar tracks and catenary wire still in place, the date of the photograph is 1936 or earlier. (BLc.)

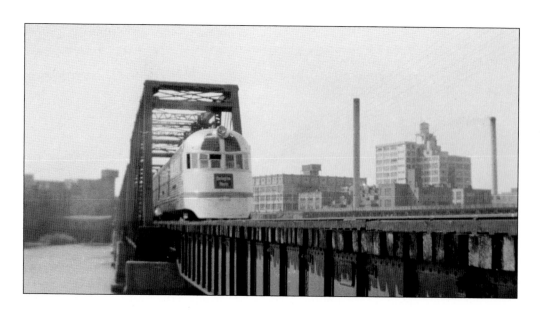

Rockford was visited by one of the most famous trains in railroading in May 1934 when Burlington's *Zephyr* 9900 (above, crossing the Rock River) came to town during its 30,437-mile, 222-city national exhibition tour. Manufactured in 1933–1934 by the Budd Company and Electro-Motive Corporation, *Zephyr* 9900 was one of the first two lightweight streamliners built and the first to employ a diesel-electric prime mover. Below, Rockfordians swarm Rockford Union Depot to examine the new travel sensation. Not long after its Rockford visit, the *Zephyr* broke a world speed record by running nonstop 1,015.4 miles from Denver to the Century of Progress Exposition in Chicago in 13 hours, 4 minutes, and 58 seconds, reaching speeds in excess of 110 miles per hour. Today the historic speedster, also known as the *Pioneer Zephyr*, greets visitors entering Chicago's Museum of Science and Industry. (Both, Roy Peterson collection.)

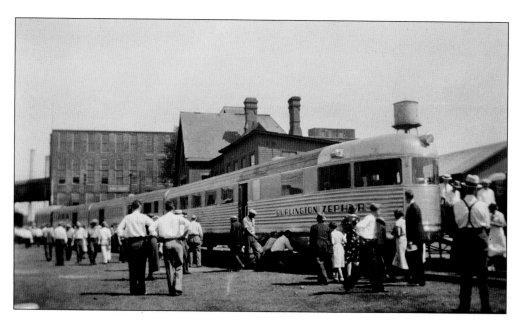

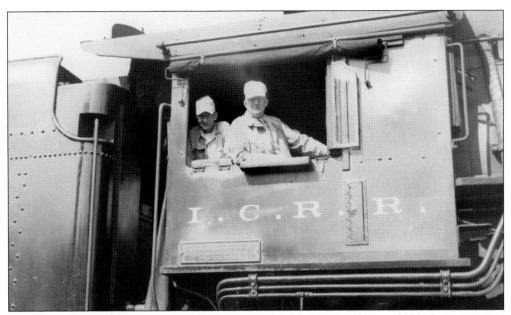

An Illinois Central engineer and his fireman pose for the photographer, probably during a train's pause at the downtown Rockford depot. The "hogger" appears to be a longtime, veteran locomotive engineer who probably went to work on the railroad not long after the turn of the century. White hats were a long-lasting tradition for IC engine crews right up into the 1960s. (BLc.)

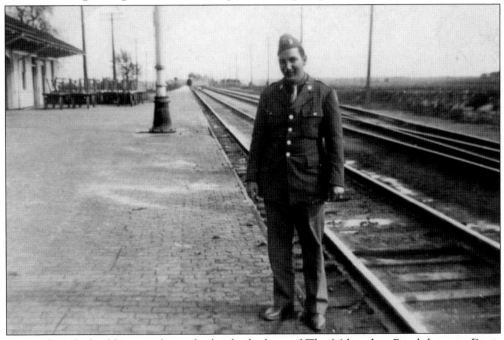

An unidentified soldier stands on the brick platform of The Milwaukee Road depot at Davis Junction around the 1930s as his westbound steam-powered train approaches in the distance. He is perhaps returning to duty at a base in the West. During the first half of the 20th century, one could still catch a through train from "D. J." to Kansas City (*Southwest Limited*) or San Francisco (*Pacific Limited*). (Roy Peterson collection.)

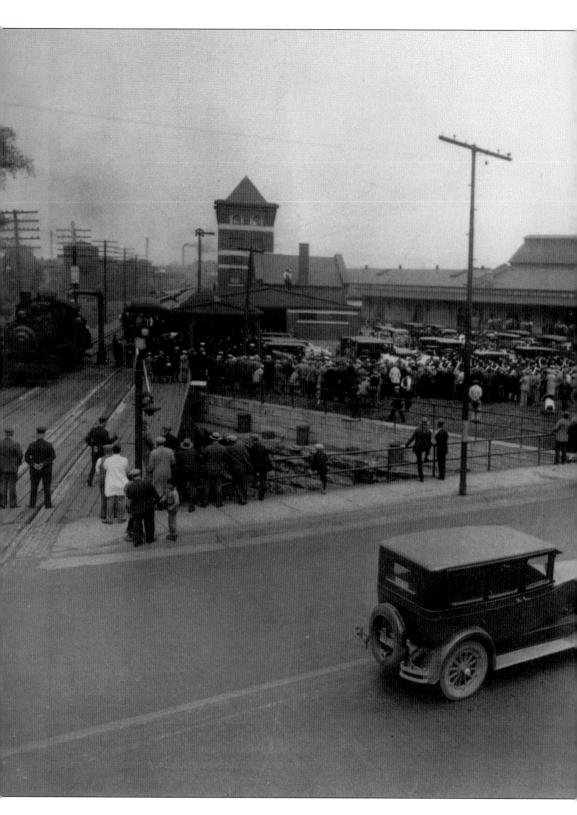

Hundreds of Rockford residents have gathered at the Illinois Central Station for what may be the arrival of First Lady Eleanor Roosevelt on November 9, 1937, at 11:30 a.m. aboard train No. 27, the *Sinnissippi*. During the Franklin D. Roosevelt presidential administration, the first lady periodically traveled about the country giving lectures. During her two-week itinerary in November 1937, she traveled with a friend on regularly scheduled trains, although it appears in this photograph that the IC provided her with a private business car attached to train No. 27. She stayed overnight at Rockford's Lafayette Hotel before heading on to Bloomington, Illinois. The photograph was likely taken from the crossing guard's two-story shanty. (BLc.)

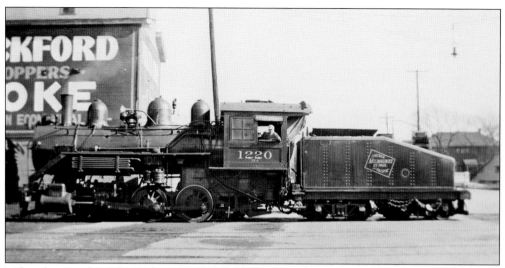

Milwaukee Road 0-6-0 switcher No. 1220, built by the railroad's Milwaukee (Wisconsin) Shops in 1908, is switching back and forth across Elm Street in September 1932. A portion of Rockford Coal and Coke's large dock facility is at left on the east side of the tracks. It stood well into the 1970s. (Roy Peterson collection.)

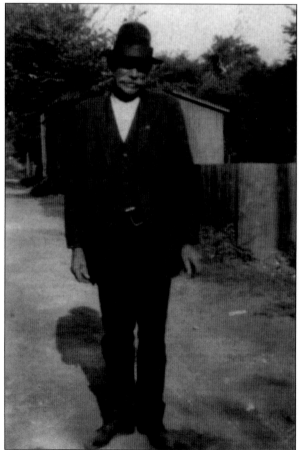

Shown around 1920, Martin C. Brennan, great grandfather of this book's principal author and a relative of movie and television star Walter Brennan, served as a section foreman for the CM&StP, making certain the railroad's Rockford-area trackage was in good condition. His brother, Robert Brennan, was an engineman on the CM&G. Other Brennan relatives also worked for Rockford railroads, and Brennans living in Rockford today are likely descendants. (Mike Schafer collection.)

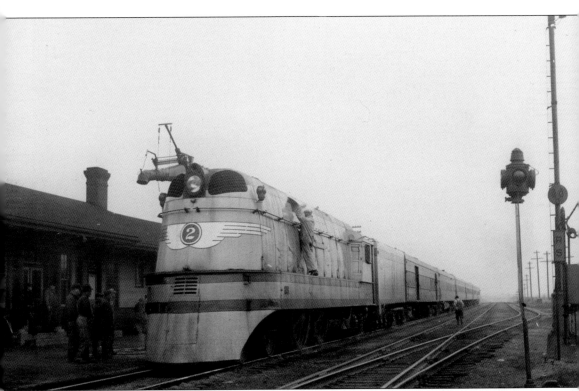

Apparently Milwaukee Road's westbound *Midwest Hiawatha*, during its passenger stop at David Junction, is experiencing some sort of mechanical problem, as evidenced by the crewman on the running board of the locomotive, checking under a shrouding panel as other railroaders look on. Inaugurated in December 1940, the *Midwest Hiawatha* linked Chicago with Sioux Falls and Omaha, crossing northern Illinois through Elgin, Davis Junction, and Savanna. The train's stop at Davis Junction allowed it to serve the Rockford market. A shuttle train, and later a jitney, on the branch between Rockford and Davis Junction provided connections to the *Midwest Hi* and other trains on Milwaukee Road's main line. (BLc.)

The sad remains of C&NW's old KD Line are shown on July 5, 1937, looking north at Harlem Road. The depot has been torn down and the rails torn up except those in the road. They would be paved over and more than 50 years later recovered by this book's coauthor, Brian Landis, to use to display his motorcar (page 127). (Roy Peterson collection.)

Its glory days a thing of the past, the abandoned Rockford and Interurban main line along Charles Street near today's Arlington Cemetery awaits the scrappers on this April 29, 1934. The view looks eastward at the west switch of siding No. 17. The 1930s were not always kind to Rockford's railroads, as the two photographs on this page reveal. (Roy Peterson collection.)

Three

ROCKFORD RAILROADING
IN TRANSITION
1941–1970

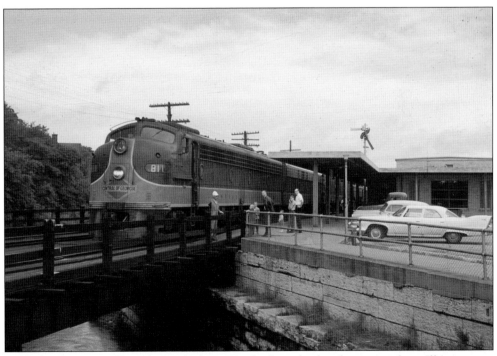

The 1941–1970 period brought much change to the face of railroading in northern Illinois, some good and some not so good. This summer 1965 scene at the Illinois Central depot in downtown Rockford reveals some of that change: a new IC depot and a new train for Rockford. The streamliner *Land O' Corn* is awaiting its 11:35 a.m. (CDT) departure time for Chicago as the engine crew talks with bystanders. (Photograph by Mike Schafer.)

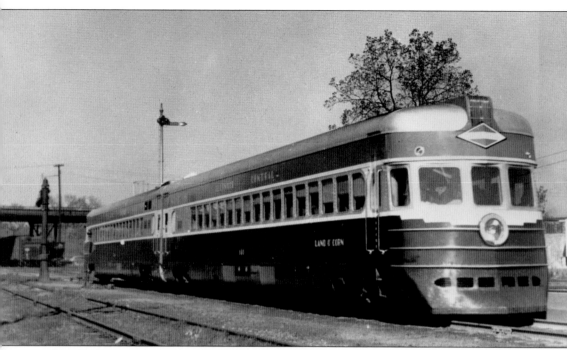

After Burlington's *Zephyr* and Union Pacific's M-10000 streamliners debuted in 1934, streamlined trains became all the rage throughout North America. They brought new appeal to rail travel, and those that were diesel powered were more economical to operate than a steam-powered train. Regularly scheduled streamliner service to Rockford began on October 28, 1941, when Illinois Central introduced its Chicago–Rockford–Dubuque–Waterloo *Land O' Corn*, shown arriving at Rockford shortly after its inauguration. Initially the service was provided by the two-car, self-propelled (by car-mounted diesel engines) American Car and Foundry "Motorailer" shown here at the Rockford Station, but in February 1942, the little train hit a beer truck near South Elgin, Illinois, and was wrecked. The impending world war precluded the Motorailer's in-kind replacement, thus the *Land O' Corn*'s schedule wound up being protected by a conventional steam-powered passenger train. (Photograph by Thomas V. Maguire; Mike Schafer collection.)

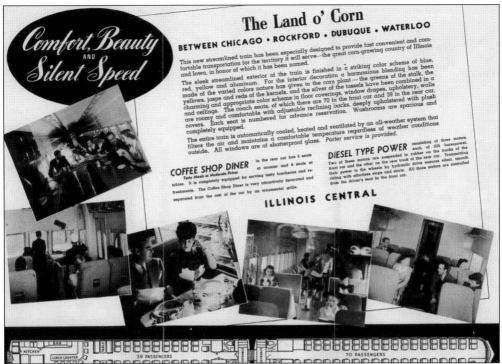

IC promoted the 1941 *Land O' Corn* with this folder showing the train's floor plan and photographs of interior accommodations. The engineer sat in the open at the front of the lead car's passenger compartment. (Would such an arrangement ever be seen today?) The rear of the train featured a lunch counter and two tables. Car interiors were painted in pastel greens, yellows, and rust—the colors found in a cornstalk. (Mike Schafer collection.)

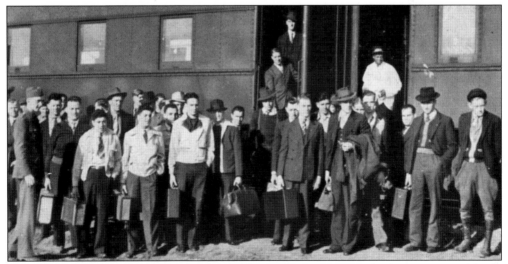

Unfortunately, 1941 confirmed the bad news that the war overseas had grown to worldwide proportions. The United States entered the conflagration on December 7, 1941, with the bombing of Pearl Harbor; consequently, Camp Grant was rebuilt. New recruits disembarking from a troop train at Camp Grant around 1941 signal the rebirth of this U.S. Army facility just south of Rockford. (BLc.)

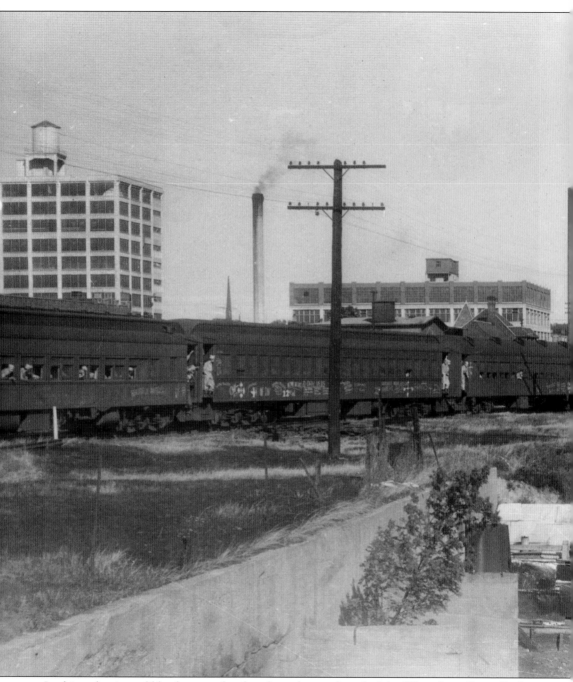

In this rather incredible photograph taken from the north end of the Winnebago Street Bridge, there is a historic, jubilant, and unusual operation taking place: the interchanging of a troop train from the Chicago and North Western down the "Ramp Track" to the joint Milwaukee Road-Burlington tracks. Soldiers have chalked the sides of the passenger cars with various D-Day exclamations, so this is clearly a troop train returning to Camp Grant in advance of sending

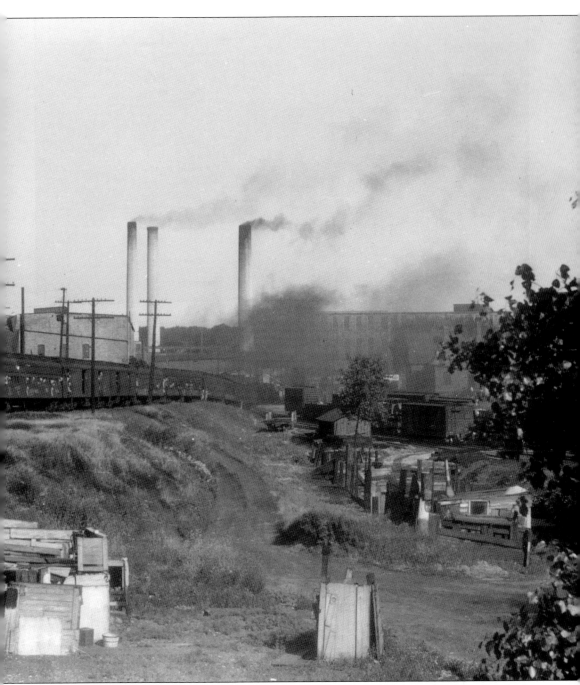

soldiers home. There are Illinois Central cars mixed in with other railroads' cars in the train, which could mean that IC handled this train from Omaha to Freeport where it was turned over to the C&NW to take to Rockford. There it was an easy and direct transfer to the Burlington—which is what is happening here—for the last short leg of the trip down to Camp Grant. (BLc.)

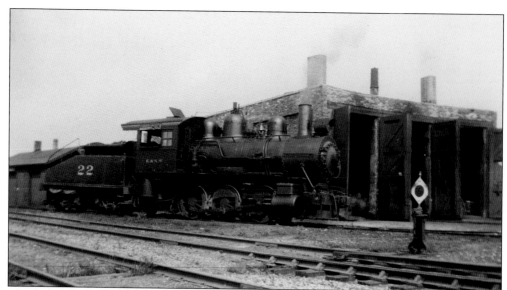

Chicago and North Western engine No. 22 is an 0-6-0—pronounced oh-six-oh (translation: no pilot wheels, six drivers, no trailing wheels)—a typical small, steam switching locomotive used by dozens of railroads of the era. This one would have been assigned local switching duties within Rockford. It is shown parked at the company's modest engine facility in Rockford just off Winnebago Street, probably early in the 1940s. (BLc.)

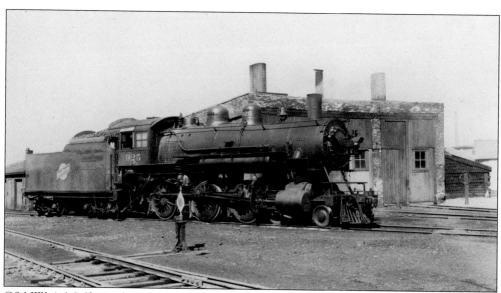

C&NW 4-6-0 (four pilot wheels, six drivers, no trailing wheels) No. 925 is on layover at the railroad's Rockford engine house, a facility that stood into the 1970s. Engine No. 925 was built by Baldwin Locomotive Works and was one of many locomotives of this type rostered by C&NW. The 4-6-0 format worked well for both freight and passenger service on secondary lines that could not handle full-size locomotives. (BLc.)

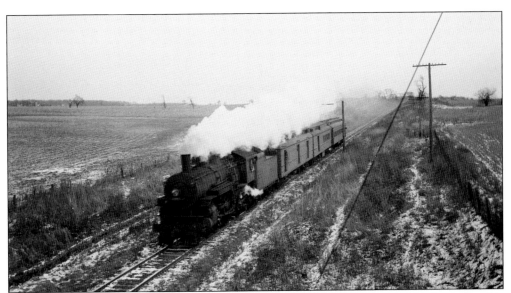

C&NW engine 126, a 4-6-0 "10-Wheeler" type (four pilot wheels, six drivers, no trailing wheels) is indeed wheeling along at Alpine Road with train 703 en route from Chicago to Freeport. The date is January 14, 1946. Today this area has been developed, and as of late 2010, Amtrak was planning to build a station nearby at the IC tracks for new Chicago–Rockford service. (Roy Peterson collection.)

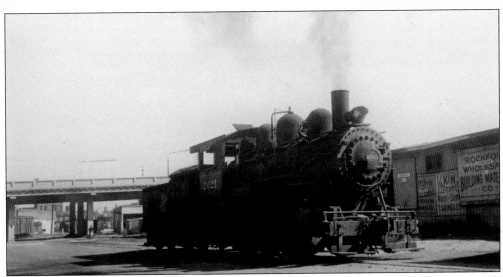

C&NW 0-6-0 No. 2021 is switching near the Jefferson Street Bridge in the 1940s. Although C&NW had ended operations on its old "KD (Kenosha Division) Line"—originally the Kenosha, Rockford, and Rock Island—beyond Loves Park to Caledonia on May 3, 1937, the remaining track served several revenue-producing customers, such as the American Chicle gum factory (today Cadbury), and remains in service in 2010—and is still referred to as the KD Line. (BLc.)

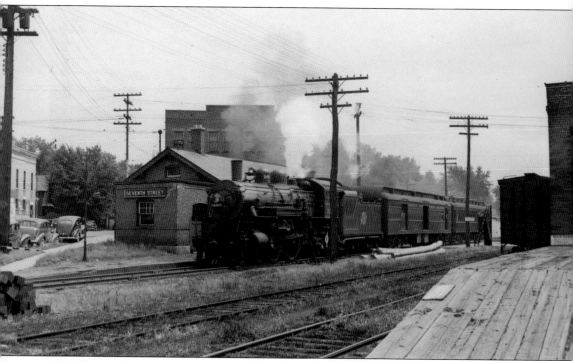

C&NW train No. 703, the all-stops local between Chicago and Freeport, steams into the station at the south end of the Seventh Street shopping district at Sixth Avenue for its scheduled 11:09 a.m. stop on a summer morning in the late 1940s. An Atlantic-type (4-4-2) locomotive leads this day's run. In C&NW timetables, this stop was referred to as "East Rockford." The original East Rockford depot stood about three blocks west of here at Fourth Street and Fourth Avenue, and in its later years, after the Seventh Street depot was built, was for a time used exclusively for incoming Swedish immigrants, including the maternal grandparents of author Mike Schafer. The brick depot in this memorable scene still stands and has been nicely restored, although in 2010, this classic passenger train of yore was long gone, by almost 60 years. (BLc.)

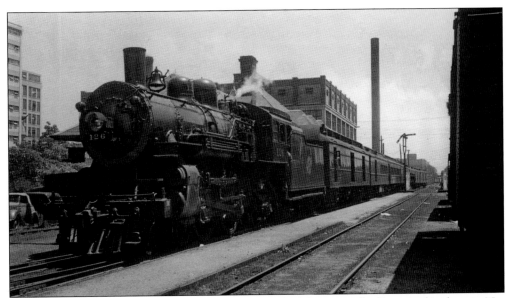

With four extra cars of express shipments at the end of the train, the Freeport local, train No. 703, has just arrived at the North Western's downtown Rockford depot at South Main and Cedar Streets on a summer day in the late 1940s. Engine No. 126, another 4-4-2 (Atlantic), was probably regularly assigned to No. 703 and eastbound counterpart train No. 706 during this period, as it shows up in other photographs. (BLc.)

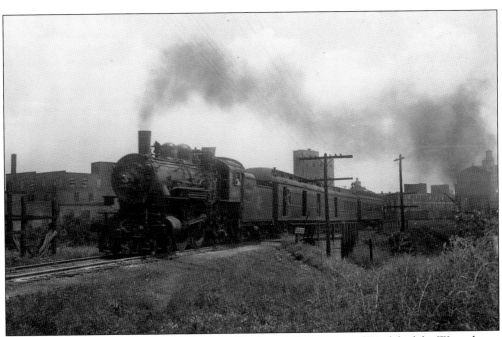

Train No. 703 has completed its station stop and now charges out of Rockford for Winnebago, Pecatonica, Ridott, and Freeport in the late 1940s. The westbound train is crossing the north fork of Kent Creek. The North Western had limited passenger service on its Freeport branch after the Great Depression since the IC offered faster and more modern services. (BLc.)

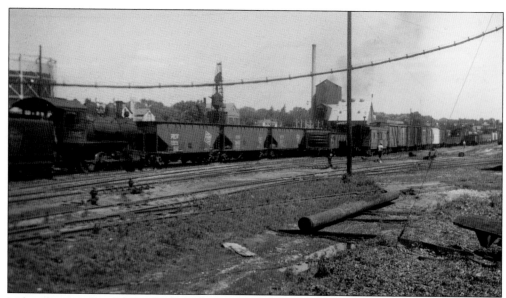

Milwaukee Road's main Rockford yard—known by crews as Upper Yard—was a compact facility that lay between Cedar and Elm Streets. This northward view of the yard from Cedar Street shows one of the Milwaukee's 0-6-0 switch engines sorting a cut of cars; the caboose at center right denotes the end of a train that is probably waiting to depart for Beloit and Janesville. (BLc.)

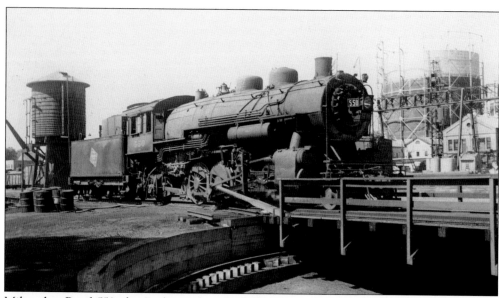

Milwaukee Road 550, shown during layover at the railroad's engine-servicing facility off Elm Street, was a Mikado-type locomotive with two pilot wheels, eight drivers, and two trailing-truck wheels—a 2-8-2 wheel arrangement (pronounced "two-eight-two"). These "Mikes" were typical over-the-road power for freight trains on secondary lines, such as those operated by the Milwaukee and Burlington to and through Rockford. (BLc.)

56

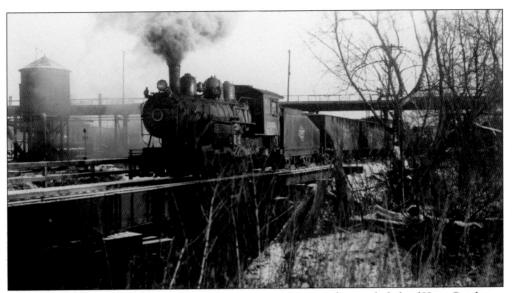

Milwaukee Road 1505, a steam switcher, is on the bridge over the north fork of Kent Creek just west of the Winnebago Street viaduct, switching some of the industries at the railroad's Lower Yard. This type of steam switching locomotive, with six small drivers and no pilot or trailing truck (allowing it to access tightly curving industrial trackage) was pretty much typical of all the railroads that assigned a switch engine to Rockford. (BLc.)

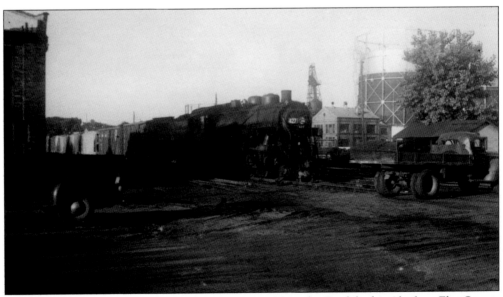

Morning sun greets Milwaukee Road 2-8-2 No. 427 at the Rockford yard when Elm Street, foreground, was still a dirt road. This is probably freight train No. 366 en route from Ladd (near Mendota), Illinois, to Janesville, Wisconsin, making its "pickups" and "setouts" before highballing for West Yard at South Beloit, Illinois. Note one of the then ubiquitous natural gas storage tanks in the background. (BLc.)

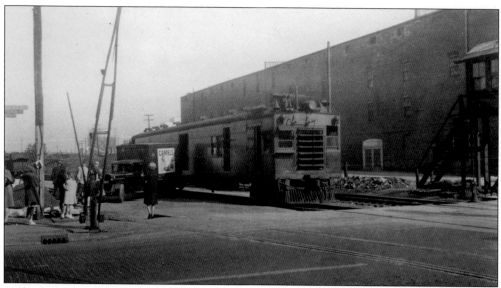

Burlington provided only limited passenger service on its Rockford branch until 1949. In later years, the service was usually provided by a gas-electric "doodlebug," shown at Rockford Union Depot at 609 South Main Street. Once loaded, the train will head for Davis Junction, Rochelle, and Aurora. Passengers could change at Davis Junction for Milwaukee Road trains or at Rochelle for a connection to CB&Q's famous *Twin Zephyr* to Minneapolis. (BLc.)

In 1946–1947, CB&Q replaced the 1880s-era Union Depot with this modern stone structure, providing both passenger and freight functions for the CB&Q and tenant Milwaukee Road. Though CB&Q and Milwaukee had ended direct rail passenger service to Rockford by 1950, one could still buy Burlington or Milwaukee Road tickets here until 1971, boarding Milwaukee Road trains at Davis Junction or CB&Q trains at Rochelle or Oregon, Illinois. (BLc.)

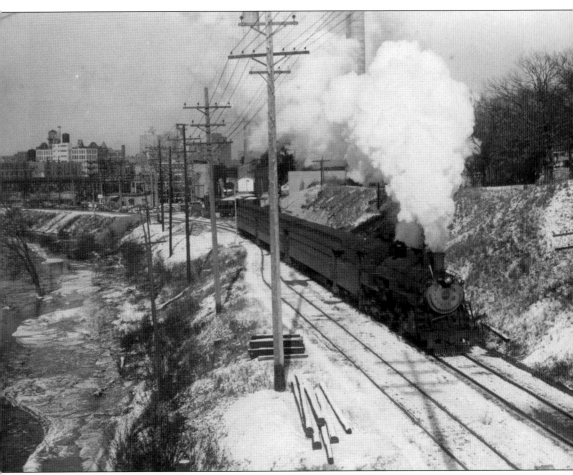

Having just left the Rockford Station and crossing the river, a southbound steam-powered CB&Q passenger train with three Chicago commuter coaches picks up speed as the photographer captures the moment from the Morgan Street Bridge sometime in the 1940s. Inasmuch as Burlington's regularly scheduled passenger train from Rockford to Rochelle and Aurora was a gas-electric motorcar that left in the morning, and this is an afternoon scene, this is probably a group charter move. Shrouded by the locomotive's steam is Fordam Power Plant, which received its coal from the Burlington; note the coal hoppers beyond the end of the train. At left in the distance is the C&NW bridge. (BLc.)

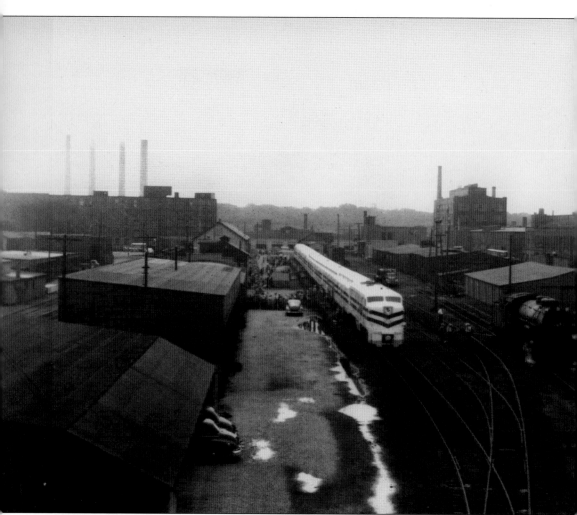

Following World War II, the National Archives, in conjunction with the American Heritage Foundation, sponsored a nationwide exhibition tour of the *Freedom Train* from 1947 to 1949. The brainchild of then U.S. attorney general Tom C. Clark, and endorsed by Pres. Harry S Truman, the special carried displays of historical artifacts pertaining to liberty, and wherever the train stopped, crowds could walk through. The train is shown on display at Rockford at The Milwaukee Road freight house on South Main Street as photographed from the Winnebago Street bridge on June 23, 1948. (BLc.)

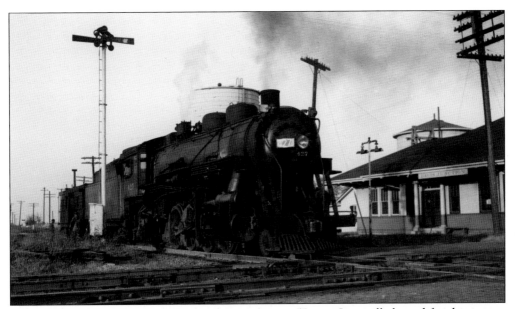

Milwaukee Road engine No. 427, also shown on page 57 on a Janesville-bound freight, is on a "caboose hop"—meaning a move that is only a locomotive and caboose—in this scene, southbound at Davis Junction. It is riding the CB&Q Rockford branch, on trackage rights, and is about to cross The Milwaukee Road's double-track main line between Chicago and Iowa. (BLc.)

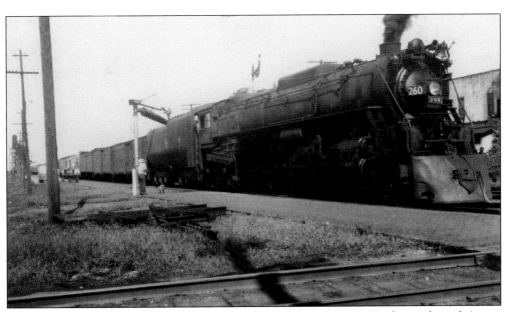

It is early morning at Davis Junction in the late 1940s as train No. 20, the eastbound *Arrow*, pauses for both passengers and water. Locomotive No. 260, one of Milwaukee Road's stable of powerful dual-service (freight and passenger) 4-8-4-type locomotives, leads the Omaha/Sioux Falls–Chicago train on this day, but diesels will soon become the norm. (BLc.)

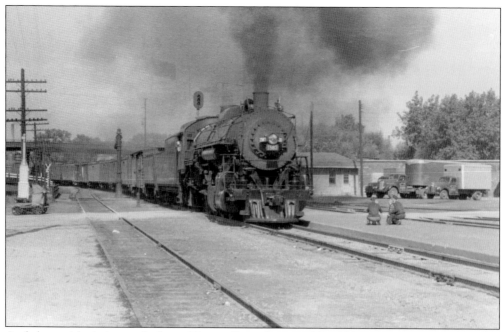

As fathers with their sons look on, Illinois Central engine No. 1583 on train No. 76, the meat train from Council Bluffs and Waterloo, storms under Winnebago Street bridge and into the station on a summer's day around 1950. With meat-laden refrigerator cars, this was the hottest freight on IC's line between the Chicago and the Missouri River and would remain so until the 1970s, when meat-processing plants began to localize and switch to trucks. (BLc.)

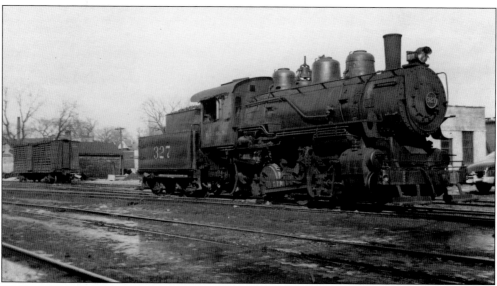

IC 327, the assigned Rockford switcher for the week, is "on spot"—meaning its crew is taking a break—in front of the IC's brick yard office just west of the Winnebago Street bridge. As with the other railroads in town, IC had a 0-6-0 switcher on hand to sort cars at its Rockford yard, which stretched from Winnebago Street west to Corbin Street. (Photograph by T. V. Maguire; BLc.)

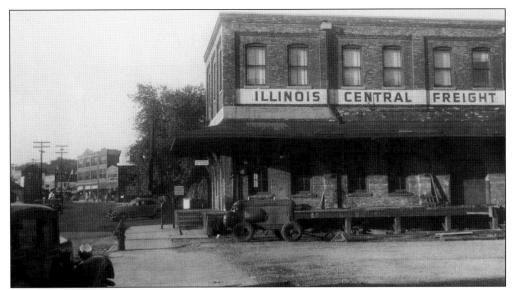

A portion of the IC freight station is shown in this view that looks southward along Main Street in the 1940s. The two-story brick building stood immediately to the north of the passenger depot, separated by the passenger parking lot. The IC main line crossed South Main Street just beyond where the automobile is pulling out of the passenger parking lot; the narrow building at left is the crossing watchman's shanty. (BLc.)

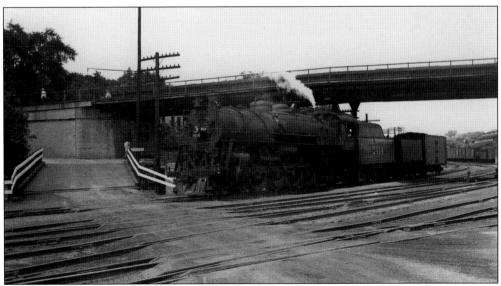

Mountain-type 4-8-2 No. 2414 heads up this day's train No. 76 between Council Bluffs and Chicago. The locomotive has uncoupled from the train with a single refrigerator car to be set out in the Rockford yard for local distribution. The 2414 will then return to its train, couple up, and resume the run to Congress Street Yard in downtown Chicago. (Photograph by T. V. Maguire; BLc.)

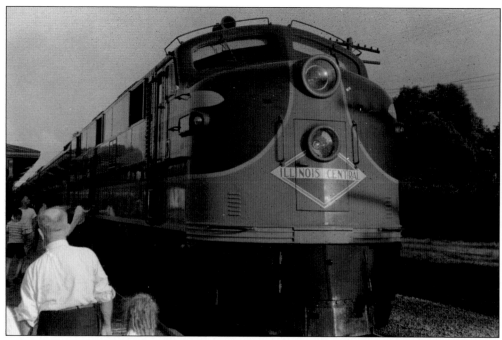

All eyes are on the newly streamlined *Land O' Corn*, having pulled into the Rockford Station from Chicago on a summer's eve, probably in 1947. After running as a steam-powered, heavyweight train since 1942 when its new Motorailer equipment was wrecked, the Chicago–Waterloo train was finally reequipped with new, lightweight coaches and cafe-lounge car on February 12, 1947. (Photograph by H. F. Patrick; Howard Patrick collection.)

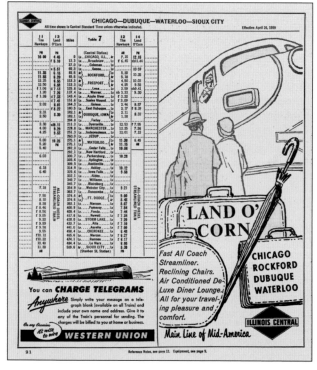

A page from an IC public timetable issued in 1959 shows the schedules of the two remaining trains through Rockford, the *Hawkeye* and the *Land O' Corn*, along with a plug for the *Corn*, as locals sometimes referred to the train. Chicago–Freeport local train Nos. 15 and 16 were discontinued in 1957. (Mike Schafer collection.)

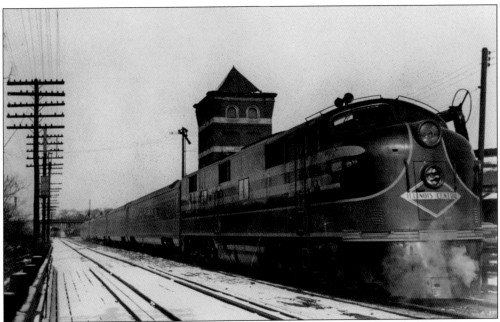

With its convenient "shoppers' schedule"—a noontime arrival in the Windy City and an early evening departure back home—IC's *Land O' Corn* was an immediate hit with Rockford families wanting an afternoon in downtown Chicago (especially at Marshall Field's department store). Pictured here, the newly equipped *Land O' Corn* shows off its new E7 diesel-electric locomotive and streamlined rolling stock at the old Rockford depot in 1947. (Photograph by T. V. Maguire; Mike Schafer collection.)

For reasons unclear, a steam locomotive has substituted for the usual diesel on an unusually long (10 cars) westbound *Land O' Corn*, pausing for passengers at Rockford in the 1950s. But train No. 13 is in capable hands: though built in 1926, engine 2459—a 4-8-2 Mountain type—is no stranger to fast passenger service. Train length may have played into the need for heavy steam. (Photograph by T. V. Maguire; BLc.)

A man and his son admire hulking 4-8-2 No. 2436 at the head end of train No. 15 making its mid-morning stop at Rockford early in the 1950s. Train No. 15, which provided a morning departure from Chicago for points west, used to be known as the *Iowan* until the run was cut back from Fort Dodge to Freeport early in the 1950s. The train was discontinued altogether in 1957. (BLc.)

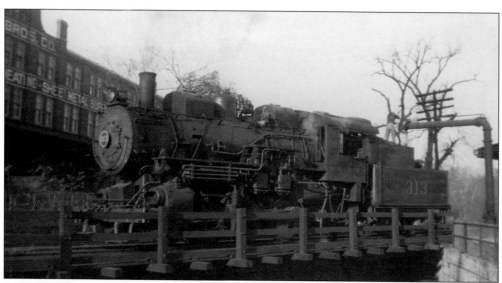

Pausing on the bridge over Kent Creek to take on water, IC switch engine No. 313 takes a break from working west-side Rockford industries and the IC yard. The water "plug" shown here was located at the east end of the downtown passenger station and used mainly by eastbound passenger trains during their passenger stop. Note the Mott Brothers factory in the background. (Photograph by T. V. Maguire; BLc.)

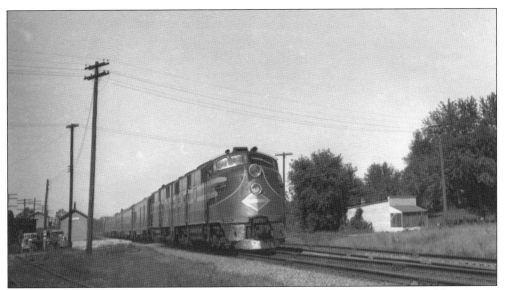

The solitude of sleepy little Perryville, Illinois, on the outskirts of Rockford, is shattered for a couple of moments as the eastbound *Land O' Corn*, train No. 14, screams across Perryville Road late in the 1940s. Two E6 diesels that normally are assigned to IC's *Panama Limited* between Chicago and New Orleans are in charge of the *Land O' Corn* today. (Photograph by T. V. Maguire; BLc.)

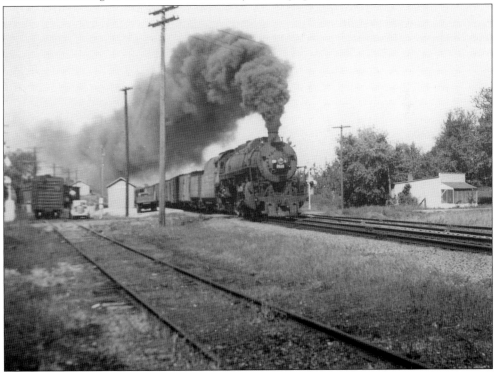

IC 4-8-2 No. 2510, built in the 1920s, is making time through Perryville with meat train No. 76 out of Iowa. This train usually followed the eastbound *Land O' Corn* into Chicago by about an hour. Its perishable lading required on-time performance for Chicago packinghouses as well as to connecting trains to the East Coast and southeast. (Photograph by T. V. Maguire; BLc.)

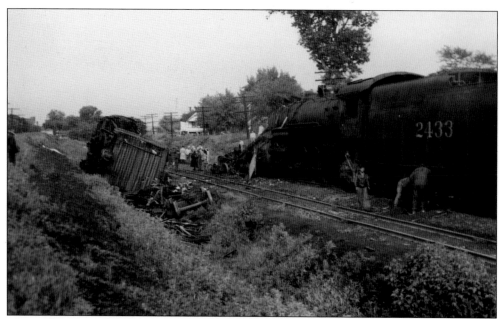

This is the aftermath of a rear-end collision that took place on the IC between today's Central Avenue crossing and Corbin Street, in the middle of Case siding. According to some reports, eastbound meat train No. 76 was running in two sections and the second section—whose engineer was running past yellow signals too fast—caught up with the first. It is believed the caboose crew jumped to safety. (Photograph by T. V. Maguire; BLc.)

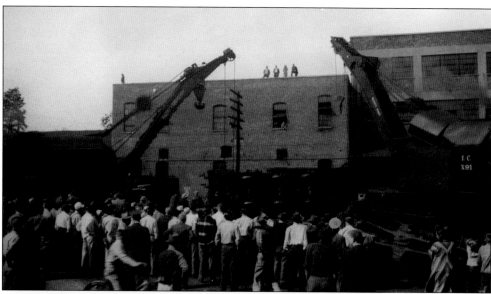

Around 1950, IC experienced a head-on collision between a westbound freight and the local switch job heading from downtown to the east side. The two trains met between the Rock River bridge and Seminary Street. Switcher No. 277 is shown being righted; the Valspar Paint building is in the background. The freight train's crew jumped to safety when they saw that collision was imminent—and lived to tell about it. (BLc.)

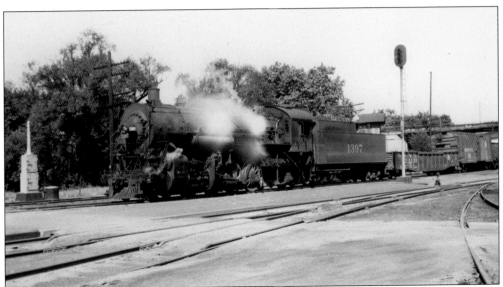

IC locomotive No. 1397, a 2-8-2 Mikado, drifts into town with a morning eastbound freight, possibly local train No. 92, which stopped to work towns between Freeport and Chicago that were bypassed by the through freights. The signal marks the start of Case siding, where trains could pass one another. The tracks in the foreground were spurs to the freight house and coal dock. (Photograph by T. V. Maguire; BLc.)

An outside-braced wood transfer caboose brings up the rear of a westbound IC local train that has just "cleared" or crossed the CB&Q's Rockford branch. A portion of the manned interlocking tower that controlled this intersection can be seen at right close to the photographer. The Joseph Behr scrap yard is behind the train and to the right of the Burlington as well. (Photograph by T. V. Maguire; BLc.)

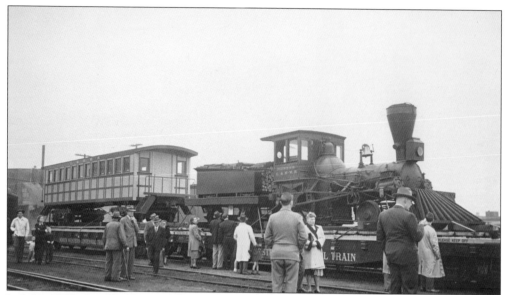

In May 1948, the Chicago and North Western Railway celebrated its 100th anniversary by dispatching its North Western Centennial Train all over its system; it is shown in North Western's Rockford yard at Winnebago Street. It included the original Galena and Chicago Union *Pioneer* locomotive (although lettered for C&NW) rather than the parade replica that had come to town in prior years (page 39). (Roy Peterson collection.)

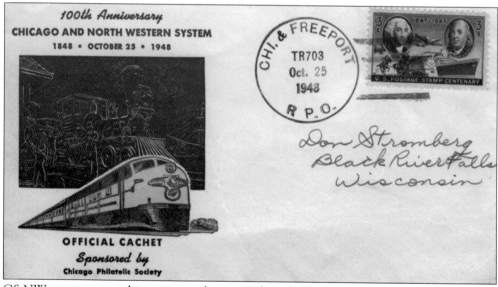

C&NW commemorated its centennial in a number of ways, including the issuance of postal cachets. The 1848 date on this one actually refers to the formation of the Galena and Chicago Union, considered the C&NW's principal predecessor. This special cachet was postmarked aboard the Railway Post Office (RPO) car of C&NW's Chicago–Freeport local, train No. 703. (BLc.)

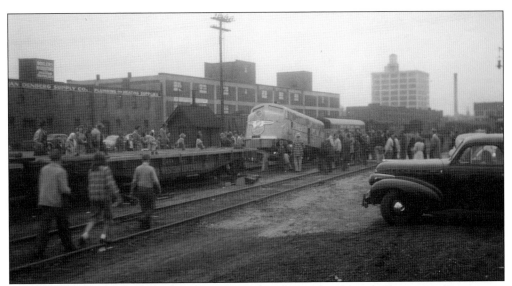

For C&NW's 1948 centennial, the railroad introduced its updated parade "locomotive"—a tractor float disguised as a miniature diesel streamliner wearing the road's familiar yellow and green livery. The parade tractor was carried to town on the North Western Centennial Train and is shown being unloaded at North Western's Rockford yard. (BLc.)

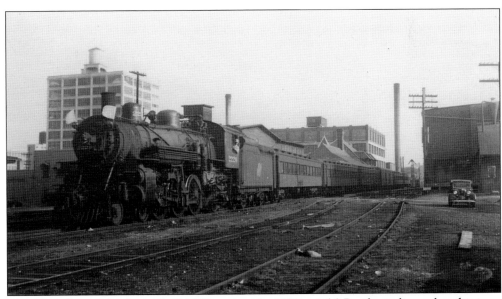

The white flags at the front of C&NW engine No. 2220, a 4-6-2 Pacific, indicate that this is an "Extra," or unscheduled train arriving at Rockford. This may indeed be a special fan-trip train for rail fans coming out to Rockford for the C&NW's centennial celebrations. The baggage car in the center of the train was serving as a food-and-beverage car, no doubt. (BLc.)

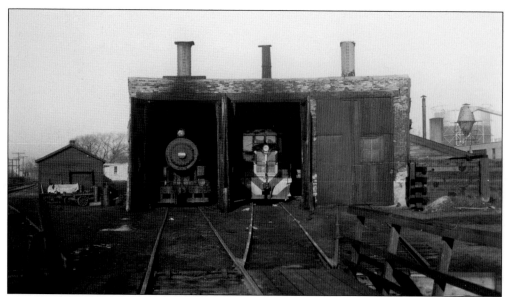

There is an interloper in Chicago and North Western's Winnebago Street engine house in Rockford: a new diesel switcher. The little center-cab locomotive No. 401 was built by the Whitcomb Locomotive Works in Rochelle, Illinois, in 1941. It is sharing the house with 0-6-0 No. 2068, which eventually will be replaced by additional new diesel switchers. (BLc.)

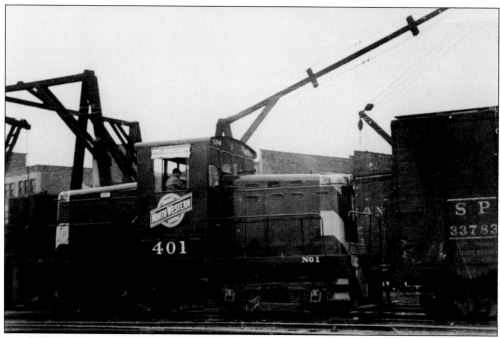

North Western's new Whitcomb diesel switcher, No. 101, assigned to Rockford, is shunting cars in the yard. The unit's yellow, green, and black livery is still bright and shiny, so it is presumed this photograph was taken early in the 1940s. Dieselization will be coming to Rockford in ever-widening circles after World War II. (BLc.)

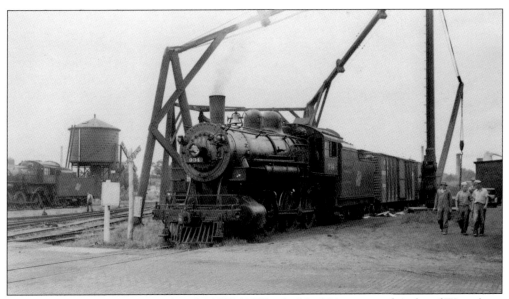

The bizarre contraption surrounding C&NW 10-Wheeler No. 934 sitting at the edge of Winnebago Street is none other than a poor man's bucket coal loading "system," installed in 1905. The C&NW did not have need for a full-fledged coal chute at Rockford, so this Rube Goldberg method was devised to lift 40-ton buckets of coal into the locomotive tenders. North Western's water tank can be seen at left. (BLc.)

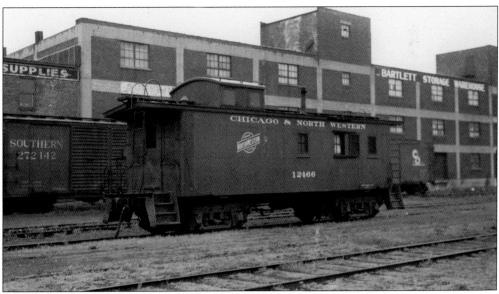

Cabooses were a familiar part of railroading that have disappeared with modernization. Before replaced by electronic rear-end protection devices in the 1980s, cabooses served as a train's "office," where the train's "office manager"—the conductor—did his paperwork, accompanied by the train's rear brakeman. This is one of C&NW's classic wooden cabooses—known as "way cars" on the C&NW—at Rockford. (BLc.)

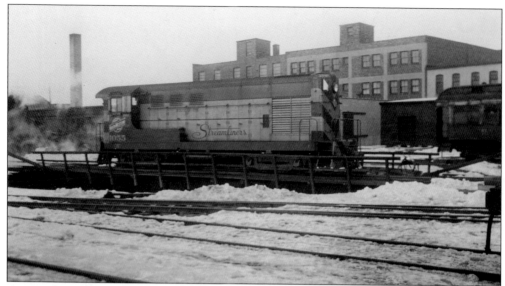

Among the early diesels that took over steam switching duties on the C&NW in Rockford was this H10-44 model switcher built in 1946 by Fairbanks-Morse (F-M) in nearby Beloit, Wisconsin. The railroad had several of these locomotives along with a bank of similar F-M H12-44s. Wearing C&NW's "Route of the Streamliners" livery, the 1055 is shown on the turntable at Rockford around 1950. (BLc.)

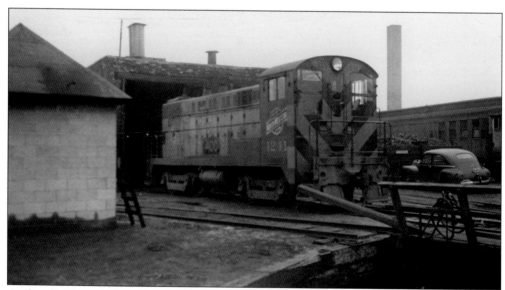

As dieselization accelerated, a wide variety of diesels began showing up on Rockford's railroads. This switcher, built by Baldwin Locomotive Works—a company made famous by building steam locomotives and whose roots dated from the 1830s—is a VO660 model, one of 10 built for C&NW in 1945. It is shown at the Rockford engine house in the late 1940s. (BLc.)

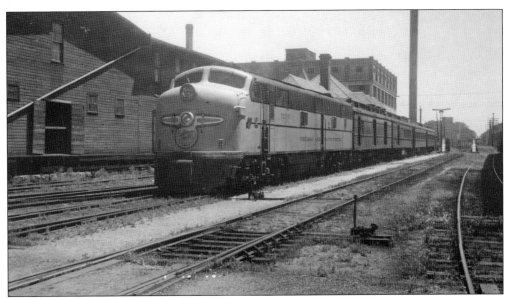

C&NW train No. 703 is shown in downtown Rockford during its twilight years after having been dieselized. The locomotive leading this day's train is No. 5013B, an Electro-Motive Division (of General Motors) E7-type passenger diesel built in 1947. This narrows the date of this photograph to between 1947 and 1950, as this train and its eastbound counterpart were discontinued on April 15, 1950, ending all C&NW passenger service into Rockford. (Photograph by T. V. Maguire; BLc.)

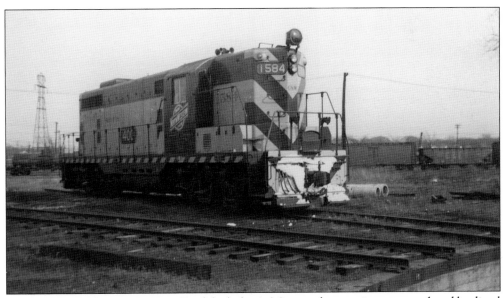

For C&NW freight trains serving Rockford, the 4-6-0 steam locomotives were replaced by diesel "road-switchers" such as this 1952-built Electro-Motive GP7 model, of which the North Western had dozens. Road-switchers were versatile in that they could be used for heavy freight service (when run in tandem with other units), branchline locals, and even passenger runs. (BLc.)

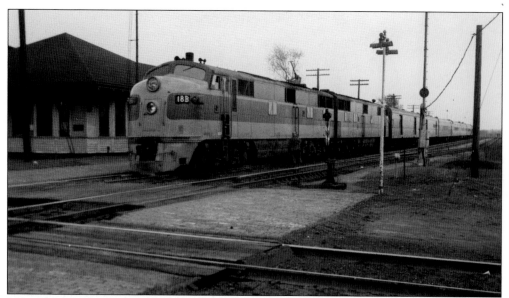

Milwaukee Road began experimenting with diesels in the 1930s but as with most other railroads, did not complete dieselization until after World War II. Here at Davis Junction in 1952, the westbound *Midwest Hiawatha* sports two EMD E7s led by unit 18B, built in 1946. These locomotives were capable of reaching speeds well in excess of 100 miles per hour, with ease. (Photograph by T. V. Maguire; BLc.)

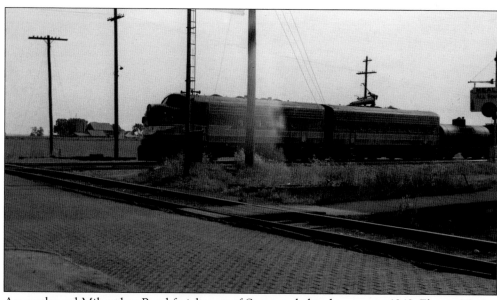

An eastbound Milwaukee Road freight out of Savanna behind a new, in 1949, Electro-Motive Division F7A&B (cab and booster) diesel set is about to cross the CB&Q Rockford branch (foreground) at Davis Junction. Off to the right, mostly out of the photograph, is the bar-restaurant known in later years as the Track Inn, a popular eating establishment until it burned to the ground in 1997. (BLc.)

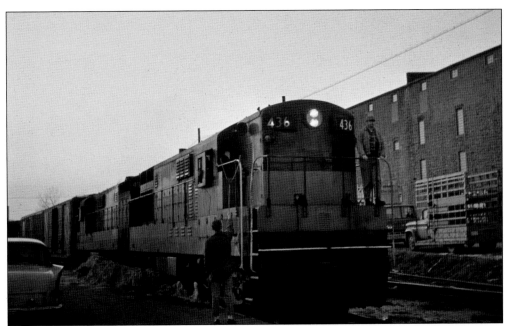

Milwaukee Road's only scheduled "time freight" through Rockford ran between Janesville, Wisconsin, and Ladd, Illinois, as train No. 366 northbound and No. 367 southbound. Here on a March evening in 1965, the Rockford depot agent-operator hands up train orders to the crew of train No. 367. Traditional power for this train in the diesel era was two or three of the railroad's large stable of Fairbanks-Morse (F-M) H16-44s—"H-Liners"—built in 1954 and 1956. (Photograph by Mike Schafer.)

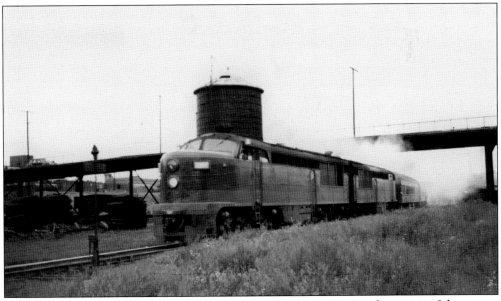

Two Milwaukee Road F-M passenger diesels of late 1940s vintage accelerate out of downtown Rockford early in the 1950s with a special passenger train, possibly a Korean War–related troop train movement. The train is heading northward under Winnebago Street and on toward Beloit. As a troop train, it might continue to Seattle, Washington, for troop deployment to the Pacific Rim by ship. (BLc.)

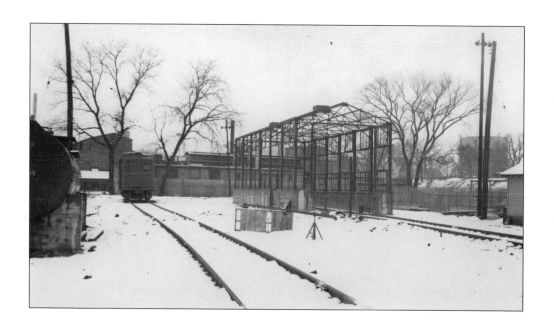

This steel skeleton (above) of a building under construction at the east end of the IC's Rockford yard in the winter of 1950–1951 portends an impending event: IC's assignment of a new diesel-electric switcher to Rockford, thereby replacing steam switching forever. In the steam era, the Rockford switcher had been kept at a small facility immediately west of Winnebago Street on the south side of the IC main line. The diesel in question (below) arrived at the new Rockford diesel house on July 1, 1951, making newspaper headlines in the process; Americans were much more railroad aware back then! Unit 9436 is an SW9 (Switcher, 900 horsepower) built in 1951 by EMD. It was renumbered to 436 several years later. Over time, other similar locomotives would be assigned to Rockford. (Both, photographs by T. V. Maguire; BLc.)

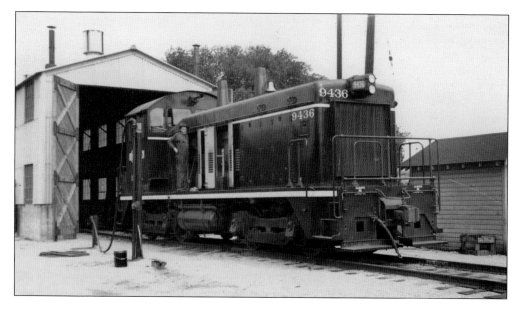

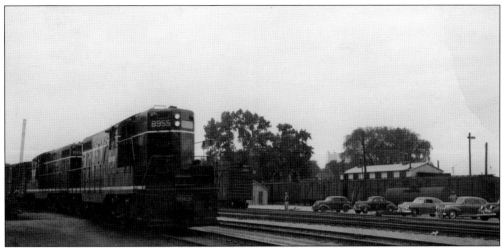

Illinois Central began dieselizing its over-the-road freights early in the 1950s with hundreds of EMD GP (for General Purpose)–series locomotives, such as the GP7 pair shown arriving Rockford with an eastbound freight around 1952. The nickname for this series of locomotives regardless of what railroad had them was "Geeps," pronounced with the "J" sound as in Jeep, the wartime utility vehicle. (Photograph by T. V. Maguire; BLc.)

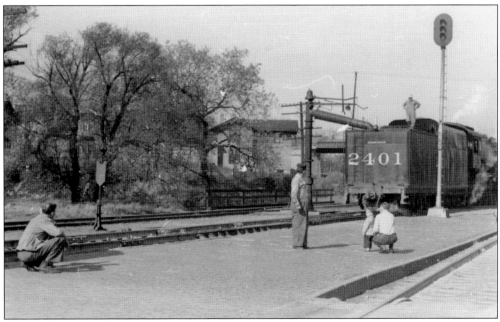

As fascinating and exciting as steam locomotives were, they, unlike diesels, were labor-intensive to maintain and needed constant attention. They were in constant need of water, which may have provided some entertainment for families out train watching at the IC depot, as in this scene, but not for IC accountants. (BLc.)

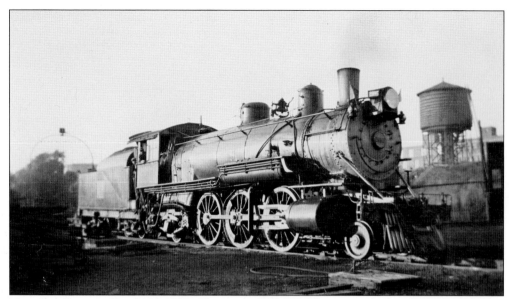

Very few photographs of "Q" (CB&Q) steam in Rockford have surfaced, probably because the way freight serving Rockford out of Rochelle tended to be a nighttime operation. This evening photograph of Burlington 2-6-2 No. 2095 at the Q's Rockford engine terminal was taken in the 1930s; it appears the engine might be getting ready to take the way freight south once the motorcar passenger run has arrived from Aurora. (Roy Peterson collection.)

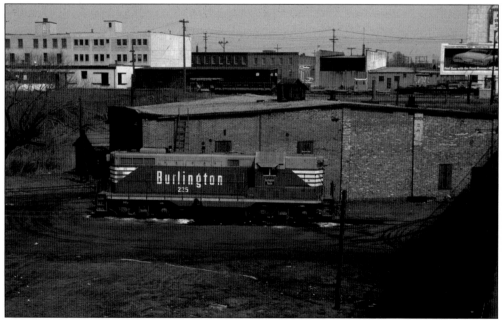

CB&Q maintained this modest engine house at Rockford immediately to the west of the Winnebago Street Bridge, from which this view was taken in May 1967. The Electro-Motive Division GP7 in this photograph was the assigned Rockford local switcher for the week. The upper-level trackage in the background is that of C&NW. (Photograph by Randy Garnhart; Jerry Pyfer collection.)

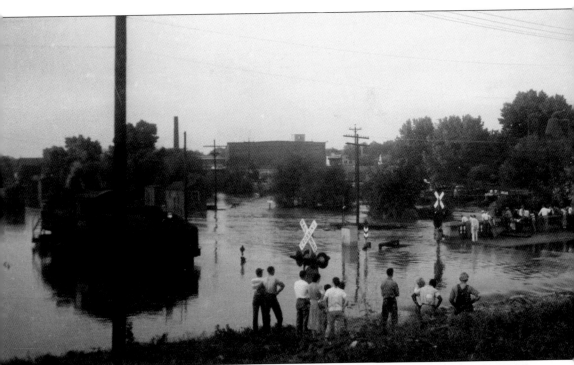

Longtime Rockford residents still talk about the great flood of 1952, when 11 inches of rain fell on July 18 and 19, 1952. Area creeks overran their banks, and the Rock River rose to record levels. Because the downtown yards of the IC, CB&Q, and Milwaukee Road were located in the valley of both forks of Kent Creek, these railroads were hit particularly hard. In this view that looks northward from a small embankment overlooking the south end of Milwaukee Road's yard, spectators gather on the Cedar Street bridge over the north fork of Kent Creek to gaze at the rushing floodwaters. Meanwhile, the Milwaukee's yard switcher stands, seemingly stranded. However, since steam locomotives are relatively unaffected by high water—unlike diesels whose axle-mounted traction motors are subject to arcing when submerged—the switcher is probably working to move freight cars to higher ground for unloading. Also, trains that had been dieselized by this time, such as IC's *Land O' Corn* and *Hawkeye*, probably were assigned steam locomotives during the flood period so that they could move through Rockford unaffected. (BLc.)

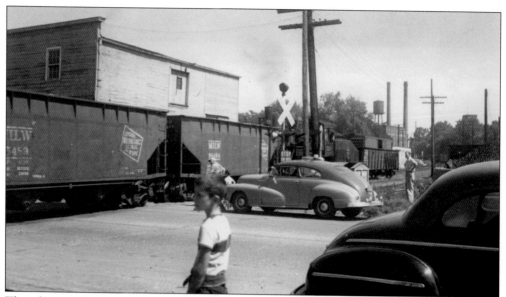

This photograph was taken at the Elm Street crossing of Milwaukee Road's line north from its Rockford yard early in the 1950s. The automobiles in this scene appear to be parked, rather than waiting for the train to clear. A closer look seems to reveal that the hopper in front of the distant automobile has experienced a minor derailment, and the crew is attempting to rerail it under the supervision of the local yardmaster. (BLc.)

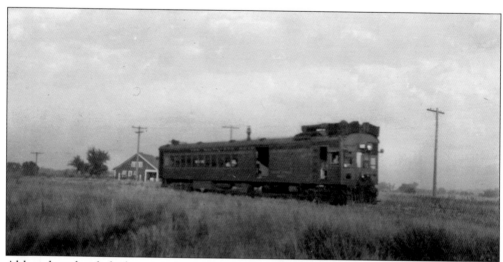

Although undated, the location on this photograph is marked "Rockford;" this is almost certainly Milwaukee Road's early morning motorcar run on its way out of Rockford to Beloit, Janesville, and Madison. Connections could be made at Beloit with Milwaukee Road's *Southwest Limited* to Milwaukee. The car would make its return run to Rockford later that day. (BLc.)

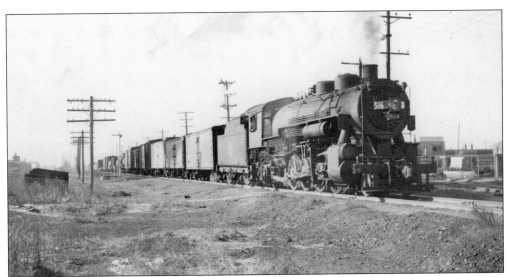

Milwaukee Road time freight No. 366 drifts into Rockford in early-morning sun during its trip north from Ladd, Mendota, and Rochelle. Mikado (a 2-8-2) No. 516 is in charge of this day's train, which at this point is riding Burlington rails at about Fifteenth Avenue. The semaphore signal a short distance back warns of the upcoming IC crossing. (BLc.)

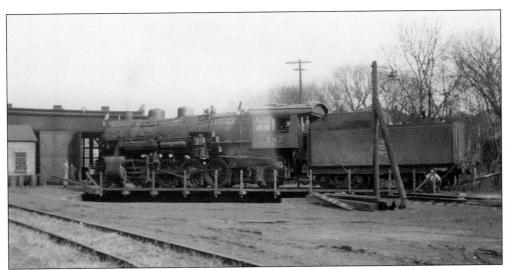

Milwaukee Road "Mike" No. 585 is being "spun" on the turntable at the Rockford roundhouse on Elm Street. It appears the 2-8-2 has arrived on a northbound train and is now being turned to head back south. This locomotive was built by Baldwin around 1920 and soldiered on to the post–World War II years and dieselization. (BLc.)

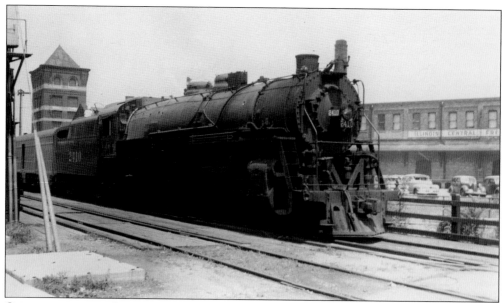

Once again, a steam locomotive—in this case Mountain type 2410—has substituted for diesels on the *Land O' Corn*, eastbound at Rockford early in the 1950s. Several IC main line trains between Chicago, Memphis, Florida, and New Orleans outranked those on the Iowa line through Rockford, and Iowa Division diesels were sometimes briefly reassigned to those trains when extra locomotives were needed. (Photograph by T. V. Maguire; BLc.)

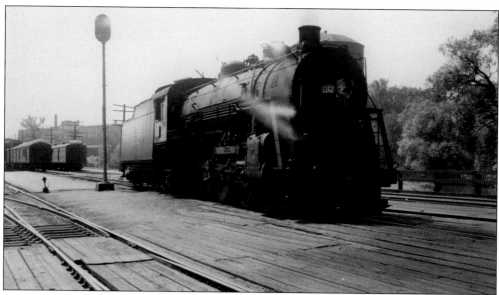

IC 4-6-2 No. 1162 has brought train No. 15 into Rockford for its late-morning passenger stop. While passengers detrain and entrain, the locomotive has set off an express car and is now about to couple back onto the train. There was still enough express business at Rockford in the 1950s to warrant a Rockford-assigned car. (Photograph by T. V. Maguire; BLc.)

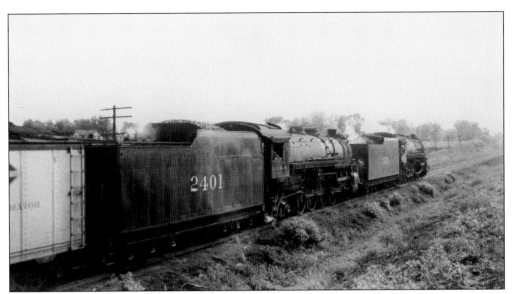

When extra power was needed for longer- or heavier-than-normal trains in the steam era, railroads often "double-headed" a run, such as shown here along Case siding west of Corbin Street about 1950. These two IC Mountains—engine Nos. 2458 and 2401—have what is probably westbound train No. 73, a Chicago–Council Bluffs run, in tow. Each engine would have its own crew. (Photograph by T. V. Maguire; BLc.)

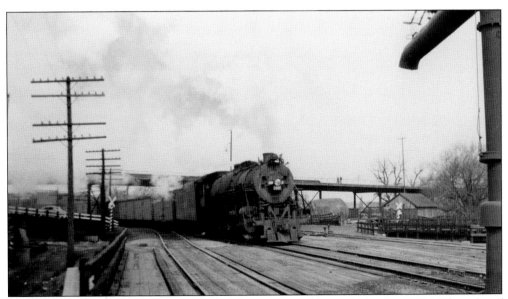

Mountain 2458 curves into the Rockford Station at midday early in the 1950s. The rake of refrigerator cars—"reefers" in railroad lingo—is a sure indication that this is meat train No. 76, which was also a "symbol" train on the IC, in this case "CC-6." That symbol indicated to railroad crews that this was Council Bluffs–Chicago train 76. (Photograph by T. V. Maguire; BLc.)

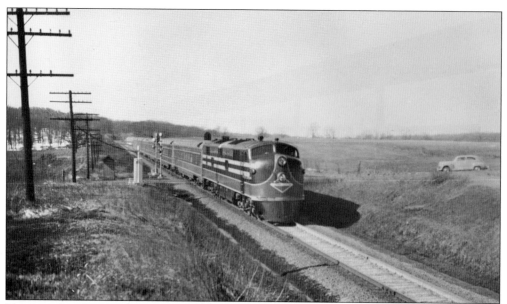

Photographer Tom Maguire, whose car is parked at right, drove to the western outskirts of Rockford for this scene of the Chicago-bound *Land O' Corn* rocketing across Pierpont Road in the late 1940s behind its single EMD E7 passenger diesel. In later years, the train usually had two back-to-back locomotives to obviate the time-consuming need to turn a single locomotive on the turntable at Waterloo. (Photograph by T. V. Maguire; Mike Schafer collection.)

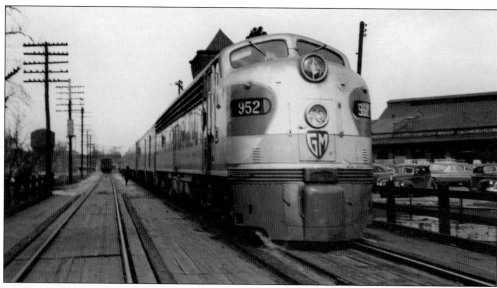

More new diesels are in the offing for IC, as this day's *Land O' Corn* has a rare visitor: an Electro-Motive Division/General Motors demonstrator locomotive—the company's new 2,250-horsepower E8 model—making a test run on March 1, 1950. The IC would buy 18 units of this model, although the demonstrator unit in this photograph would wind up being bought by the Rock Island Lines. (Photograph by T. V. Maguire; BLc.)

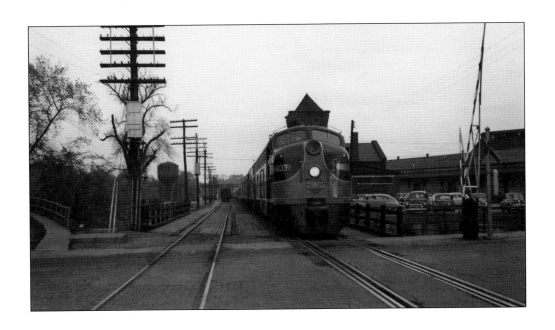

A denizen of the darkness, the early-morning *Hawkeye*, train 12, pauses at the old Rockford depot. An E8 and E7 locomotive pair leads the overnighter from Sioux City. This photograph has to have been taken in the spring of 1953 inasmuch as lead locomotive 4033, a new EMD E8, was built that year and teardown of the old depot began on May 19, 1953. Below, back-to-back E7s have a 15-car *Hawkeye* in tow between Ninth and Tenth Streets, site of IC's old East Rockford Station. The *Hawkeye* was the most important passenger train on IC's line to Iowa. It made direct connections at Chicago with IC's *City of Miami* and *City of New Orleans* as well as trains to the east on the New York Central, Pennsylvania Railroad, Baltimore and Ohio, and Erie Railroad. (Both, photographs by T. V. Maguire; BLc.)

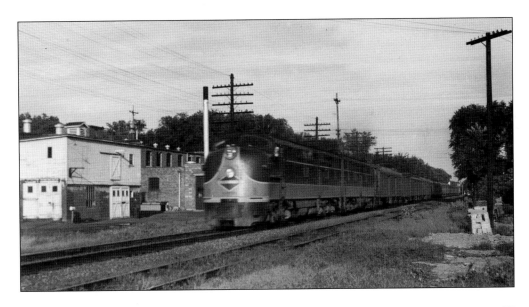

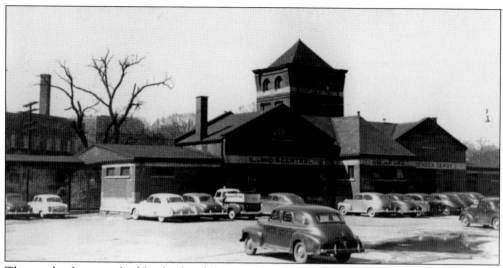

The rarely photographed backside of the 1880s-era Illinois Central depot is shown in this photograph taken from the IC freight station about 1950. The Mott Brothers building, at left in the distance across Kent Creek, was once served by the IC. The company was sold to Columbia Pipe in 2001, but the old building remains standing in 2010. (BLc.)

After more than 60 years of serving Illinois Central patrons at Rockford, the stately brick structure has caught the wrath of a wrecking ball in this view from South Main Street during the summer of 1953. The new depot will be built on the same site, requiring the IC to serve passengers out of temporary facilities, such as the walled-in portion of the old platform canopy at left. (BLc.)

IC's new Rockford depot was dedicated at a special luncheon at the Hotel Faust on June 24, 1954, about a year after the depot replacement project began. This was no small affair. The railroad sent out elegant invitations and published a special dedication booklet; the cover and one page are shown here. Over 30 officers from IC's headquarters in Chicago came out for the event, including esteemed IC president Wayne A. Johnston. Rockford itself was represented by Mayor Milton Lundstrom and other city officials as well as the officers of many Rockford manufacturing establishments, including Atwood Vacuum, W. F. and John Barnes, J. I. Case, Rockford Machine Tool, Barber Coleman, and Woodward Governor. All of this illustrates the close relationship railroads and cities had in that era and the importance of a railroad on a town or city's well being. (Mike Schafer collection.)

Dedication Program

ILLINOIS CENTRAL PASSENGER STATION
ROCKFORD, ILLINOIS

ILLINOIS CENTRAL

Luncheon

HOTEL FAUST
FRIDAY, JUNE 4, 1954

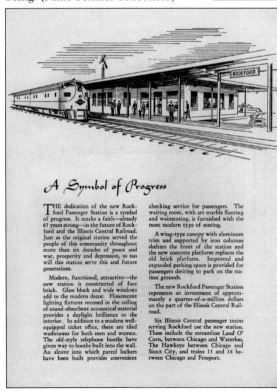

A Symbol of Progress

THE dedication of the new Rockford Passenger Station is a symbol of progress. It marks a faith—already 65 years strong—in the future of Rockford and the Illinois Central Railroad. Just as the original station served the people of this community throughout more than six decades of peace and war, prosperity and depression, so too will this station serve this and future generations.

Modern, functional, attractive—the new station is constructed of face brick. Glass block and wide windows add to the modern decor. Flourescent lighting fixtures recessed in the ceiling of sound-absorbent accoustical material provides a daylight brilliance to the interior. In addition to a modern well-equipped ticket office, there are tiled washrooms for both men and women. The old-style telephone booths have given way to booths built into the wall. An alcove into which parcel lockers have been built provides convenient checking service for passengers. The waiting room, with art marble flooring and wainscoting, is furnished with the most modern type of seating.

A wing-type canopy with aluminum trim and supported by iron columns shelters the front of the station and the new concrete platform replaces the old brick platform. Improved and expanded parking space is provided for passengers desiring to park on the station grounds.

The new Rockford Passenger Station represents an investment of approximately a quarter-of-a-million dollars on the part of the Illinois Central Railroad.

Six Illinois Central passenger trains serving Rockford use the new station. These include the streamline Land O' Corn, between Chicago and Waterloo, The Hawkeye between Chicago and Sioux City, and trains 15 and 16 between Chicago and Freeport.

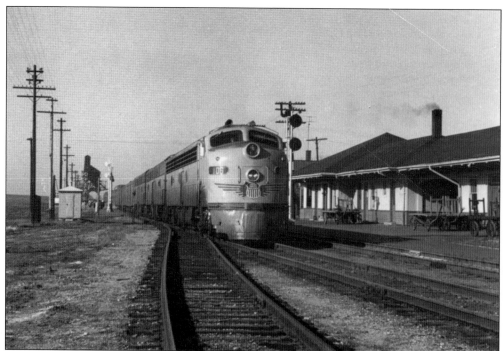

In October 1955, Union Pacific transferred the Omaha–Chicago leg of its famous Domeliner and Streamliner train fleet from Chicago and North Western's Omaha main line through Rochelle to Milwaukee Road's Omaha main line. This brought transcontinental passenger train service to Rockford's doorstep at Davis Junction. Here in Davis Junction in November 1955, the eastbound *Challenger* from Los Angeles makes its morning station stop. (Photograph by Howard Patrick.)

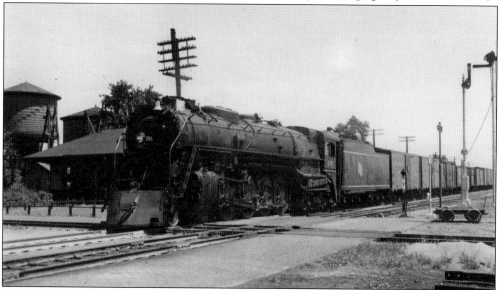

Milwaukee Road engine No. 207, leading a westbound freight into Davis Junction, represents a member of Milwaukee Road's most modern and power fleet of steam locomotives, the S-class 4-8-4s (generally known as "Northerns" on those railroads that had them). As with Rockford, steam power at Davis Junction lasted into the 1950s. The 207 was retired in 1955. (BLc.)

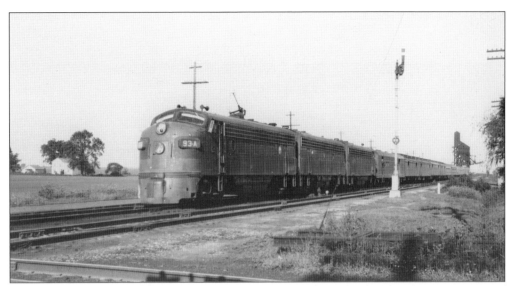

As was often the case, passenger trains tended to get priority for dieselization on account of improved acceleration and less dwell time required for engine changes or coaling and watering. An FP7-F7B-FP7 trio of new EMD locomotives built around 1950 leads this morning's *Arrow*, just into Davis Junction from Sioux Falls and Omaha. Like its competing train, IC's *Hawkeye*, Milwaukee Road's *Arrow* carried a lot of mail and express. (BLc.)

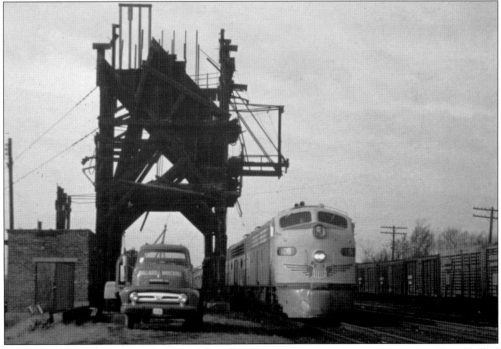

With dieselization complete on The Milwaukee Road's main line through Davis Junction, Ballad Wrecking Company has the dubious honor of dismantling the landmark wooden coaling tower that stood west of the depot in December 1956. Meanwhile, the eastbound *City of Portland* from Portland, Oregon, brakes for its stop at the junction to detrain Rockford-bound passengers. (Photograph by Howard Patrick.)

For author Mike Schafer, Saturday mornings in the mid-1960s meant heading downtown with his friends to the Burlington-Milwaukee Road depot on South Main Street where agent-operator Russ Hansen often invited them to ride the CB&Q's Rockford switch job with the train crews. During one such trip, the photographer was able to capture the departure of C&NW's local for Freeport as he was about to board the CB&Q locomotive. (Photograph by Mike Schafer.)

The city is just emerging from a January snowstorm in 1966 that closed city schools, but for area railroads it was just another day. Pictured here, Chicago and North Western's Rockford switch job has just come off "the Horn" branch that snakes through Churchill Park and is momentarily blocking Eleventh Street with a flatcar of new equipment from the Plasser Railway Maintenance Equipment Company at Twentieth Street and Seventh Avenue. (Photograph by Mike Schafer.)

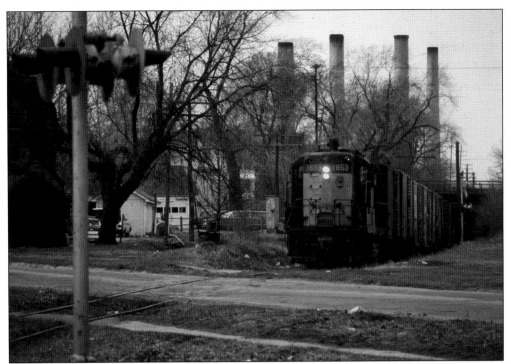

With the landmark Fordam power plant's quartet of stacks as a backdrop, the C&NW's daily local trudges up the hill from the Rock River bridge to Fourth Street (foreground in photograph) on its way back to West Chicago in 1970. The train is at the site of the C&NW's original station for East Rockford, later the immigrant's station. (Photograph by Mike Schafer.)

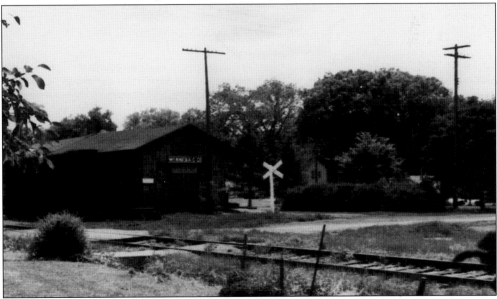

The old C&NW depot at Winnebago looked a little worse for wear in this scene from around 1965. The C&NW pulled out of Freeport on August 1, 1972, and truncated the Freeport line at Winnebago, on the outskirts of Rockford. On September 29, 1981, the C&NW pulled out of Winnebago, truncating its operations at Rockford. (BLc.)

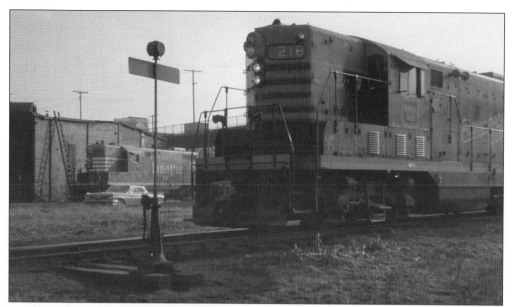

Two locomotives pose at the Chicago, Burlington, and Quincy's modest engine-servicing facility below Winnebago Street Bridge in spring 1965. The locomotive at left next to the roundhouse is the assigned Rockford switcher, while GP7 No. 218 at right has just arrived from Rochelle with the way freight. (Photograph by Mike Schafer.)

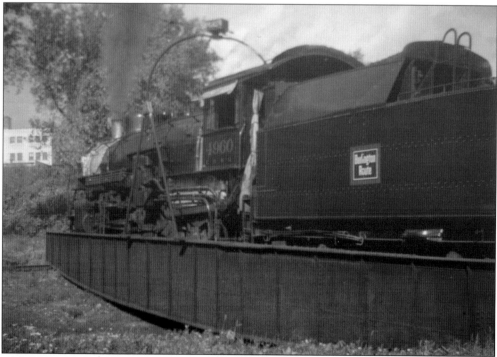

Although CB&Q was a pioneer in dieselization, it did not ignore the past, even after dieselization was completed by the 1960s. The railroad kept two steam locomotives active for excursion service: 4-8-4 No. 5632 and for secondary lines, 2-8-2 No. 4960. The latter made several trips to Rockford over the years. Here, in 1964, she gets turned on the turntable at Rockford. (Photograph by Mike Schafer.)

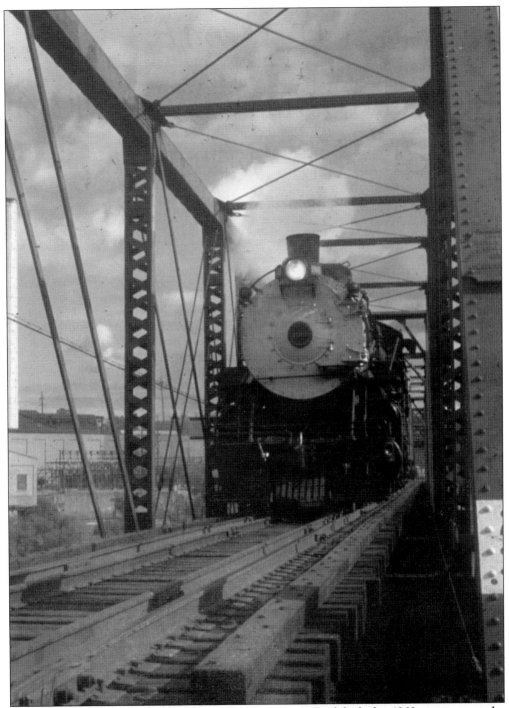

During its December 1964 "Steam Zephyr" excursion to Rockford, the 4960 struts across the Rock River bridge. Though built during the World War I period for low-speed freight service on secondary main and branch lines, the 4960 has spent a considerable portion of its life hauling passenger excursion trains. Retired from Burlington service in 1966, the engine today serves on the Grand Canyon Railway in Arizona. (Photograph by Dale Jacobson.)

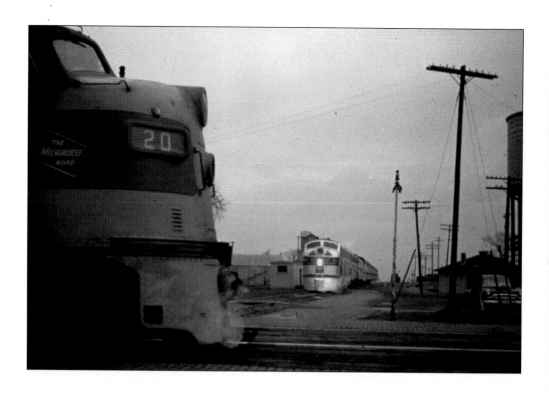

Of all four Rockford railroads of the 1941–1971 period, the Burlington was easily the most civic minded. Every year through 1964, the railroad sponsored a student special from Rockford to Chicago so that kids could tour the "Windy City." In this April 1956 scene at Davis Junction (above), the annual student excursion out of Rockford waits for Milwaukee Road's eastbound *Arrow* to depart, thus clearing the path ahead for the CB&Q special. CB&Q was a highly respected carrier throughout its history, serving Rockford industries, such as Atwood Vacuum Machine (below), through its 23-mile ex-Chicago, Rockford, and Northern branch. Even after direct CB&Q rail passenger service to Rockford ended in 1949, the railroad continued to operate Burlington Trailways buses between Rockford, Oregon, and Rochelle to connect with main line passenger trains. (Above, photograph by Howard Patrick; below, BLc.)

STATEMENT		**Chicago, Burlington & Quincy R.R.Co.**			No. 252160	
					252160	
C.O.D. INVOICE NO.	OTHER SERVICE	PERIOD			1692 Rockford, Ill.	Station
		FROM	TO			
ORIGIN	UTILITY BILL					
WB NO. & DATE	P. U. & D.	2/1/56	4/30/56			
CONSIGNEE	JCT. SETLMT.				May 10, 1956	
REFUND WB C/N NO.	OTHER					
DATE REPORTED						

Pay to the order of **Atwood Vacuum Machine Company** $2.80

The sum of **Two and 80/100***Dollars.**

To Treasurer, C.B.& Q.R.R.Co.

Payable Through
The First National Bank of Chicago, 2.
Continental Illinois Nat'l. Bank and Trust Co. of Chicago, 2-3 Agent.

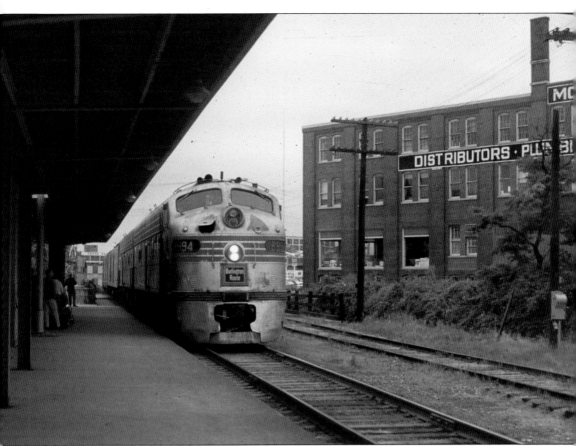

For four days in August 1967, Rockford railroad enthusiasts were treated to the sight of Burlington passenger trains passing through town because of CB&Q's need to detour around a bridge-related mishap near Galena on its Chicago–Rochelle–Oregon–Savanna main line through northern Illinois. Here the Chicago–Twin Cities *Morning Zephyr* arrives at the Illinois Central depot en route to East Dubuque. To do the detour, this train left its regular route near Rochelle, traveled to Rockford on CB&Q's Rockford branch all the way to Burlington's Rockford depot two blocks north of the IC depot, then backed up to recross the Rock River and begin a 1-mile-long crawl along an industrial spur that began at the Behr and Sons scrap yard. The backup move through the spur took the train onto the IC main line at Eleventh Street. There the train reversed direction to continue (forward) west on the IC to East Dubuque, Illinois, where it returned to its regular CB&Q route and vice versa for eastbound trains. The situation made Rockford news, and residents flocked to trackside to watch the unusual moves. (Photograph by Mike Schafer.)

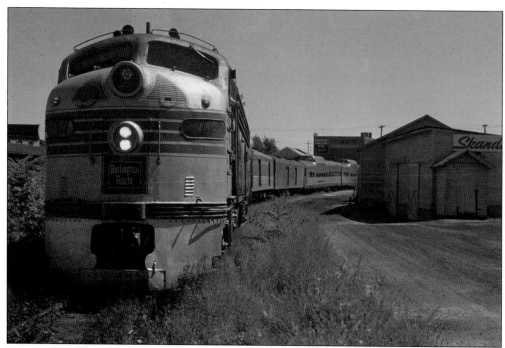

The Burlington detour story of August 1967 continues. Above, this is the Minneapolis-bound *Morning Zephyr* inching its way backward through the twisting industrial spur track known by local railroad crews as the "Angle Worm" to get from CB&Q tracks to IC tracks. The train is backing through Skandia Lumber property between Eighth and Ninth Streets. Below, author Mike Schafer had an opportunity to ride through Rockford on one of the detours. From his vantage point in one of the train's Vista-Dome cars, he recorded this scene of the Chicago-bound *Morning Zephyr*, which has just come in from East Dubuque on the IC main line. The train has stopped just east of Eleventh Street and Rockford Standard Furniture and is about to reverse direction to begin the arduous backup through the "Angle Worm." (Both, photographs by Mike Schafer.)

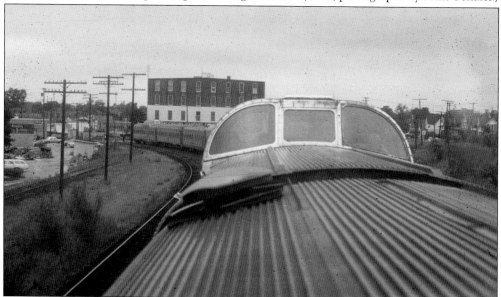

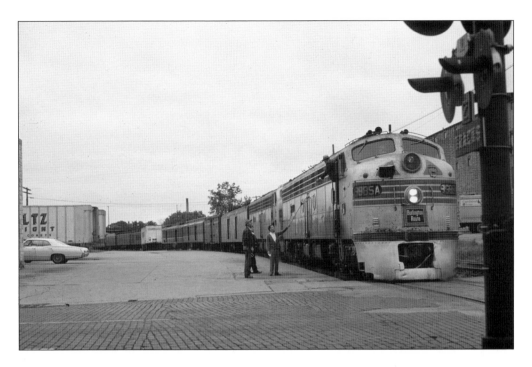

Shortly after dawn during one of the detour days (above), the combined *Blackhawk/Mainstreeter/Western Star*—three trains in one—has just arrived from Seattle and Minneapolis-St. Paul at CB&Q's Rockford Station on South Main Street. In the dark of morning, it had negotiated the backup part of the detour and is now about to head forward to Rochelle and Chicago. On the last day of the detours, a minor mishap occurred (below) when a kitchen fire broke out in CB&Q dining car *Silver Cuisine* on the *Morning Zephyr*. It had to be removed from the train and parked at Seminary Street so that the Rockford Fire Department could douse the fire. Damage was minor, and as of 2010, this very same dining car was now owned and operated by Amtrak. (Above, photograph by Mike Schafer; below, photograph by Jim Boyd.)

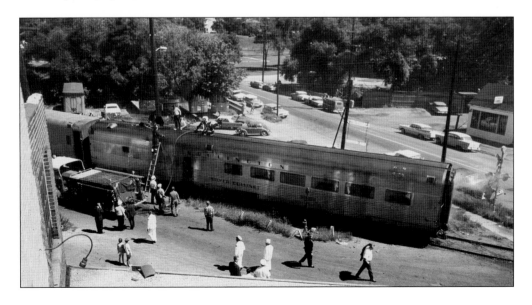

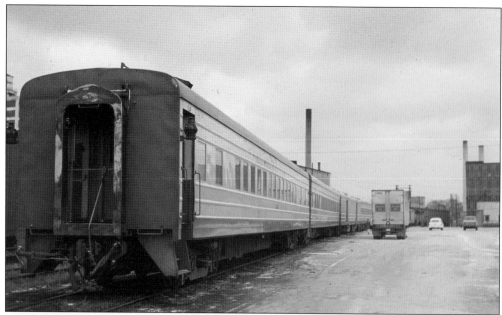

Regularly scheduled passenger service at Rockford on The Milwaukee Road ended in 1949, but Milwaukee Road passenger trains occasionally returned in the form of special charter moves. Such is the case here at the joint CB&Q-CMStP&P depot at 609 South Main Street in February 1965 with the arrival of the equipment for Rockford Jaycee's annual ski train special to Iron Mountain, Michigan. (Photograph by Mike Schafer.)

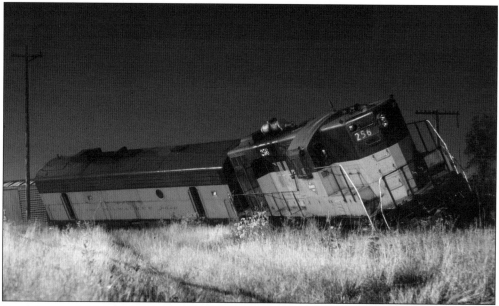

Vandals caused this relatively minor wreck near Greater Rockford Airport. The miscreants threw a switch in front of Milwaukee Road's evening Janesville–Ladd freight train No. 367, causing its two locomotives to jackknife. The slow speed limit on Burlington's Rockford branch kept the situation from being far worse. (Photograph by Mike Schafer.)

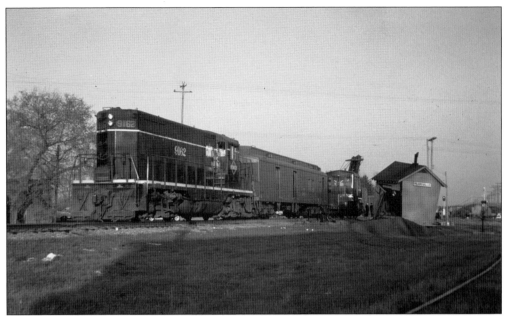

A freight-train derailment on the Illinois Central at Perryville in spring 1961 took out the Perryville depot once and for all. It is late afternoon, and the "big hook" has been brought to the wreck site by IC GP9 No. 9162. In a couple more decades, a very similar wreck would occur at the very same location. (Photograph by Howard Patrick.)

When Milwaukee Road's "Gary Job" switch run suffered a minor derailment behind Rockford Standard Furniture at Parmele Street in 1966, neighborhood kids were invited by the engine crew to come up into the engine cab while the train crew waited for a track crew to arrive to help rerail the gondola car. (Photograph by Mike Schafer.)

Westbound IC freight No. 71—which also went by the symbol CC-1 (for Chicago–Council Bluffs, train 71)—is parked in Buckbee siding (above) just east of the Eleventh Street crossing on a gray day in March 1966 to clear the main line for eastbound meat train No. 76. Woe to the train dispatcher who delays the meat train! Below, during the previous year in February 1965, there was another "meet" in progress as train No. 71 (at right) trundles along Buckbee siding as oncoming meat train No. 76 highballs for Chicago. Train No. 71 will reenter the main line at Eighth Street, where Buckbee siding ends. (Both, photographs by Mike Schafer.)

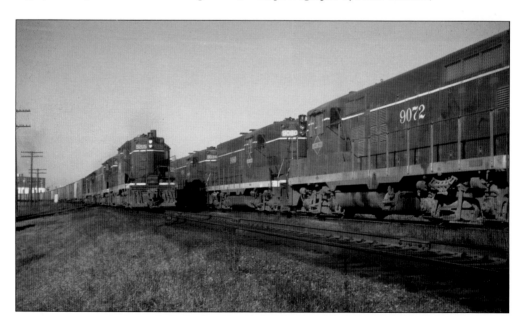

Mail is being transferred to and from the RPO (Railway Post Office car) on IC train No. 11, the westbound Chicago–Sioux City *Hawkeye*, during its 15-minute stop at Rockford in the late 1960s. As the train moved through the night, postal employees sorted mail for towns and cities near or on the train's route. With the sorting done en route, mail back then could be delivered faster. (Photograph by Jim Heuer.)

The overnight *Hawkeye* provided Pullman sleeping-car service until 1968. During the *Hawkeye*'s Rockford stop, one evening shortly before the sleepers were removed, this smartly uniformed sleeper attendant stood at the ready to assist boarding passengers to their private roomettes and bedrooms. Unfortunately there were too few first-class passengers to keep sleeper service going. (Photograph by Mike Schafer.)

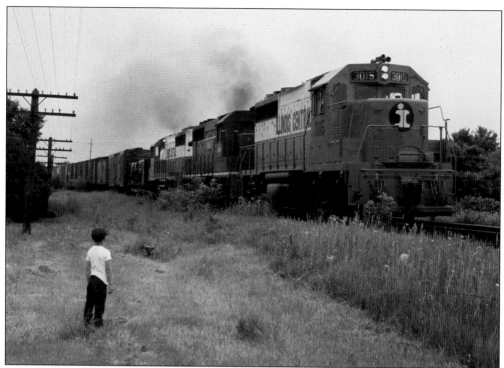

With his Cubs cap firmly in place, young Donny Gulbrandsen is mesmerized by the awe of thundering diesels charging out of Rockford on a summer day in 1969 with IC train No. 78, a Waterloo–Chicago freight. By this time, IC's new-image herald and orange-and-white livery was replacing the austere black that had been worn by IC freight diesels since World War II. (Photograph by Mike Schafer.)

The author, who at the time of this 1969 photograph worked for Carlson Commercial Photography studio in Rockford, took this photograph of westbound IC train No. 73 at Eleventh Street. Friends Richard Dean and Joe Petric are perched upon a turn-of-the-20th-century-era track-inspection velocipede, restored by historian Mike McBride of Dixon. They are about to take it for a spin on the old CM&G track that is almost invisible in the weeds. (Photograph by Mike Schafer.)

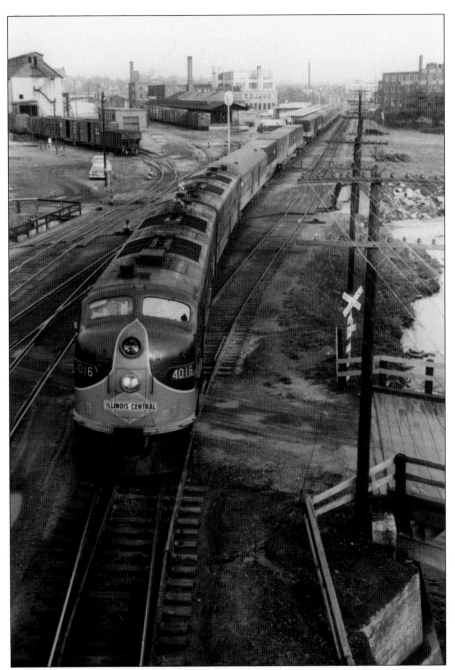

Illinois Central's westbound *Land O' Corn* has just arrived the downtown Rockford Station following its 86-mile, 90-minute dash (which included stops at Broadview and Genoa, Illinois) from Chicago's Central Station on a summer evening in 1965. What looks like freight cars back in the train are actually Flexi-Van trailers used to handle express and sealed mail to Dubuque and Waterloo. Alas the *Land O' Corn* is living on borrowed time; it can no longer compete with Greyhound, which—along with the general public and their new automobiles—got new, fast "tracks" in the form of the Northwest Tollway in the late 1950s. In two more years, the *Land O' Corn* will be history. (Photograph by Mike Schafer.)

IC conductor Levi Markley, of Freeport, is shown standing by the *Land O' Corn* during its Rockford stop in summer 1967 shortly before the train's discontinuance. Levi worked both the *Hawkeye* and the *Land O' Corn* and was a familiar, friendly face to regular riders on the IC between Dubuque and Chicago, his regular route. (Photograph by Mike Schafer.)

Riding the train to Chicago was a rite of passage for Rockfordians. On the Saturday after Thanksgiving 1963, brothers Paul (left) and Mark Magnuson have just stepped off the *Hawkeye* at Central Station in Chicago where they pose on the pedestrian bridge over the IC. (Photograph by Mike Schafer.)

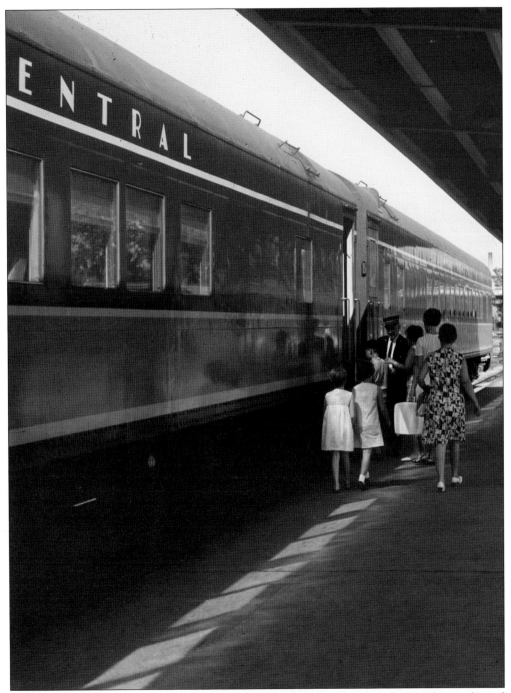

A mother and her son and daughters, among a handful of others, board IC's Chicago-bound *Land O' Corn* just a day or two before the train's last run on August 3, 1967. Patronage on this Waterloo–Chicago passenger train nose-dived after the Northwest Tollway opened in the mid-1950s. The *Land O' Corn*'s discontinuance left Rockford with but a single passenger train, the Sioux City–Chicago *Hawkeye*. (Photograph by Mike Schafer.)

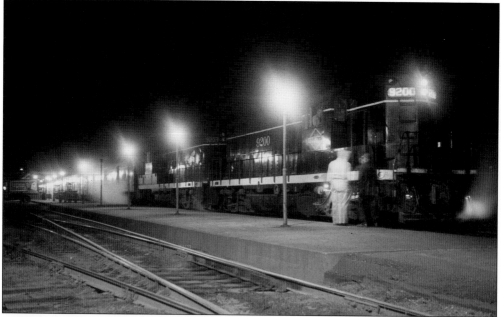

Following the 1967 discontinuance of the *Land O' Corn*, the *Hawkeye*, shown westbound at the Rockford depot in October 1965, was Rockford's only remaining passenger train until it too was discontinued when Amtrak took over most U.S. intercity rail passenger service come May 1, 1971. Unfortunately Amtrak's paltry startup capital was not enough to initially include Rockford in its system. (Photograph by Mike Schafer.)

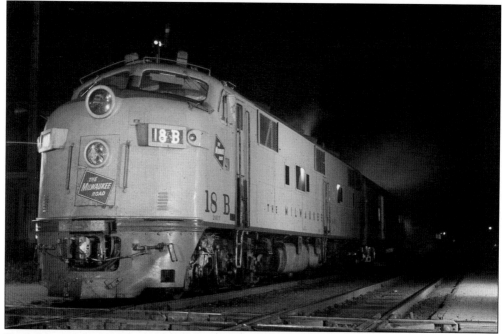

Davis Junction was not faring well either in the passenger-train department. On October 6, 1967, the Chicago–Omaha *Arrow*, shown westbound during its Davis Junction stop late on a summer evening in 1966, was discontinued. (Photograph by Mike Schafer.)

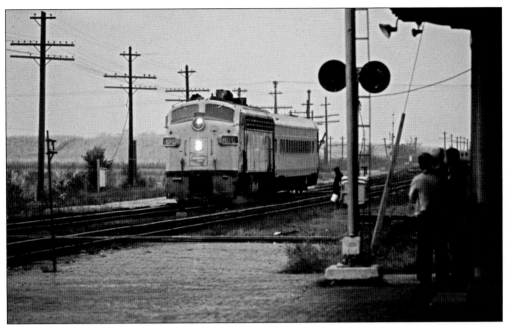

Service curtailments even struck the famous Union Pacific *City* train fleet. This one-car Milwaukee Road train (above) arriving at Davis Junction in summer 1970 is what replaced—by State of Illinois mandate—the schedule slot vacated across northern Illinois when the *City of Denver/City of Portland* was combined with the *City of Los Angeles/City of San Francisco* late in 1969. At that point, there was but one remaining *City* train between Chicago and Omaha (below): the combined *City of Denver/City of Portland/City of San Francisco/City of Los Angeles*, with the various trains being separated en route at North Platte, Nebraska; Green River, Wyoming; and Ogden, Utah, to branch out to their respective namesake destinations. The westbound "City of Everywhere" is shown during its Davis Junction stop in fall 1970. (Both, photographs by Mike Schafer.)

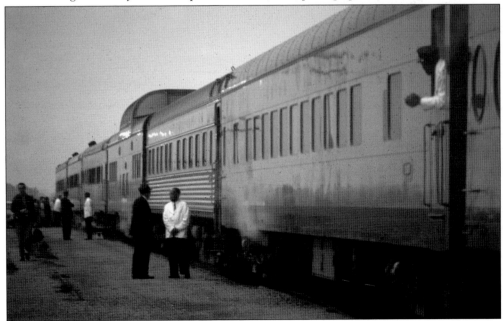

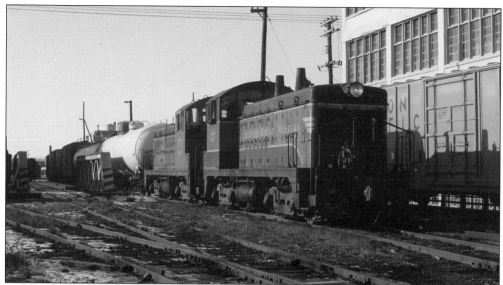

Following C&NW's 1968 merger with the Chicago Great Western Railway, CGW locomotives began showing up in Rockford on occasion. These two red CGW switchers crossing the South Main Street overpass were working the Rockford yard in January 1970. With C&NW as the dominant partner in the merger, eventually CGW locomotives would be repainted in C&NW yellow and green. (Photograph by Mike Schafer.)

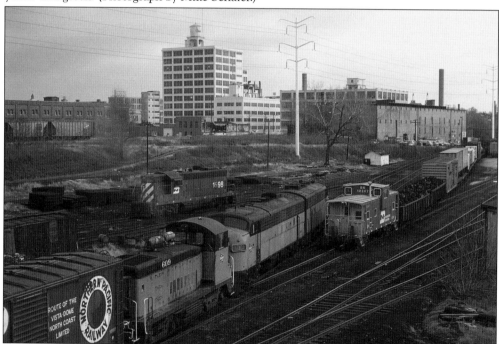

On March 2, 1970, Rockford got its first new railroad in several decades when the Chicago, Burlington, and Quincy; the Great Northern; the Northern Pacific; and the Spokane, Portland, and Seattle merged to form the Burlington Northern. In this scene from the Winnebago Street Bridge, Milwaukee Road's southbound freight from Janesville passes green-and-white BN motive power and a caboose. (Photograph by Mike Schafer.)

110

Four

ROCKFORD AREA RAILROADS
1971–2000

With the City of Rockford Fourth of July downtown fireworks display as a backdrop, Illinois Central Gulf locomotive No. 1776, *The American Eagle*, stands proudly on display at the ICG/Amtrak passenger station on July 4, 1976. The locomotive wore a special paint scheme commemorating the nation's bicentennial. (Photograph by Mike Schafer and Randy Olson.)

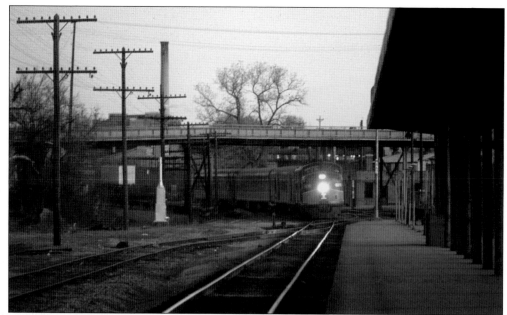

The 1970s began on a low note in the annals of Rockford railroad history with the May 1, 1971, discontinuance of Illinois Central's *Hawkeye*, shown arriving at Rockford early one morning shortly before the end. By this time, the Chicago–Sioux City train was down to only three cars. Its termination ended all scheduled rail passenger service to Rockford for the first time in almost 120 years. (Photograph by Mike Schafer.)

On August 10, 1972, another "new" railroad arrived at Rockford. On that date, the Illinois Central merged with the Gulf, Mobile, and Ohio to form Illinois Central Gulf. With Barber Coleman's Rock Street plant as a backdrop, an ICG coal train rolls eastward over the World War I–era deck girder bridge across the Rock River on June 2, 1979, behind a mixture of ICG and old IC locomotives. (Photograph by Jerry Pyfer.)

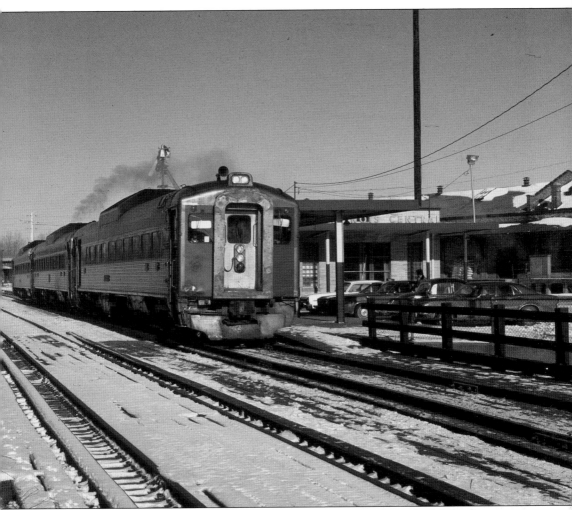

Rockford got a nice Valentine's Day present on February 14, 1974, when scheduled rail passenger service resumed over ICG's former Illinois Central route between Chicago and Dubuque, Iowa. On that date, the Illinois Department of Transportation and Amtrak launched the *Black Hawk*, running on a schedule not unlike that of the late, lamented IC *Land O' Corn*. Initially utilizing secondhand, self-propelled RDCs—rail diesel cars—that had built for the now-defunct New Haven Railroad early in the 1950s, the *Black Hawk* is shown at the refurbished Rockford Station during the winter of 1974–1975. (Photograph by Jerry Pyfer.)

To celebrate the bicentennial of the American Revolution, the *American Freedom Train* was created by the American Freedom Train Foundation for a two-year tour of the United States. The 26-car train, using steam and diesel power, made extended stops at some 140 cities, of which Rockford was one. The train arrived at Rockford on August 7, 1975, traveling up Burlington Northern's former-CB&Q Rockford branch en route from its previous engagement at Crystal Lake, Illinois. It is shown in both photographs passing through Davis Junction. Because of weight restrictions on the branch, the train had to be hauled by one of BN's bicentennial-painted diesels (above) while the steam locomotive moved up separately. The crew of a westbound Milwaukee Road freight holding for the *AFT* (below) enjoyed its passing as well. (Both, photographs by Jerry Pyfer.)

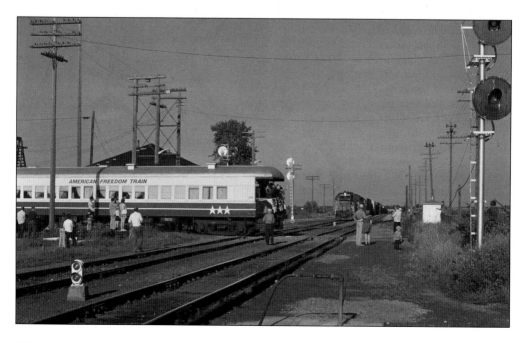

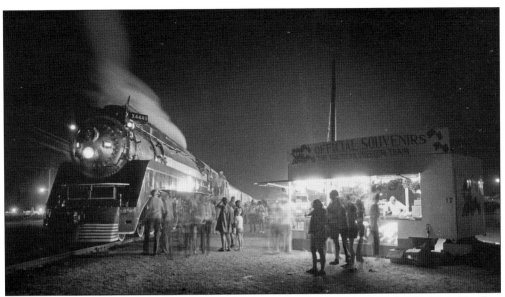

To best accommodate the throngs of Rockford-area people who came to view the *American Freedom Train* during its August 1975 visit to Rockford, the train and its ancillary components, such as the souvenir stand shown here (above), were positioned at BN's Camp Grant siding near Greater Rockford Airport. Restored former Southern Pacific 4-8-4 steam locomotive No. 4449, built in 1941, powered the train west of Chicago. The train's 10 display cars carried treasured American artifacts such as one of Judy Garland's dresses from the *Wizard of Oz*, George Washington's copy of the U.S. Constitution, and a moon rock. The locomotive was as much an attraction as the displays (below). Pictured here, visitors chat at eye level with the train's engineer, Doyle McCormack. (Both, photographs by Mike Schafer.)

The *American Freedom Train* offered postal cachets at each display location. The train itself was considered a postal station, as the stamp on this postcard indicates, but the stamp was changed to indicate the display location for each stop. (BLc.)

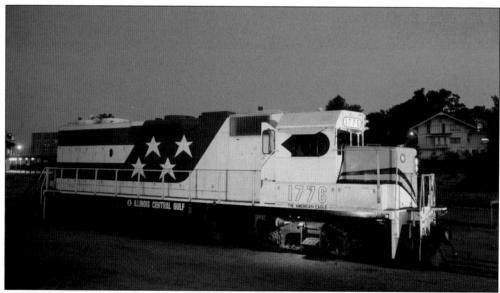

On July 4, 1976, the North Western Illinois Chapter of the National Railway Historical Society arranged for Illinois Central Gulf to display its bicentennial locomotive at Rockford. ICG No. 1776 was painted to resemble an eagle, with the locomotive's yellow nose representing a beak, the side cab windows the eyes, and the flanks painted with winglike designs. The famous locomotive poses with Tinker Swiss Cottage in the background. (Photograph by Mike Schafer.)

Rockford's pioneer railroad, the Galena and Chicago Union, was in a sense represented as well at Rockford on July 4, 1976, when the Chicago and North Western parked its own red, white, and blue bicentennial unit No. 1776 on the old KD Line—originally the Kenosha, Rockford, and Rock Island—just north of State Street by Rockford Furniture Mart. The C&NW and G&CU merged in 1865, one hundred and sixteen years before this scene was recorded. As with the ICG's *American Eagle*, the NWI Chapter-NRHS arranged for the C&NW to have its locomotive on hand on this historic date. (Photograph by Mike Schafer.)

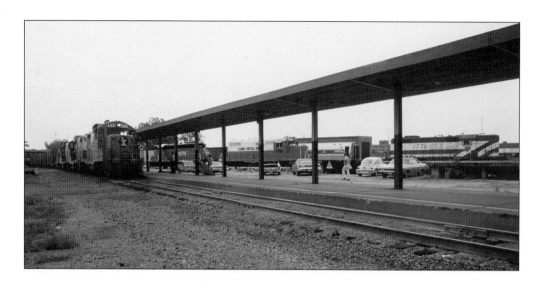

The year 1977 yielded yet another celebration for Rockford railroading, as this was the 125th anniversary of the arrival of the first railroad in Rockford. To spotlight this event, the North Western Illinois Chapter of the National Railway Historical Society arranged to have Rockford's railroads place equipment on display at the ICG station grounds (above) on August 12 and 13, 1977. ICG, BN, and C&NW each contributed a locomotive while Amtrak brought in a new passenger car; Milwaukee Road, by this time near bankruptcy, declined. Rockford residents tour the exhibit as an eastbound ICG freight passes by. The exhibit culminated on the eve of August 13 (below) with a speech by then Rockford mayor Robert McGaw (at left in light suit) and the arrival of Amtrak's *Black Hawk* from Chicago on August 13, breaking a banner. (Both, photographs by Mike Schafer.)

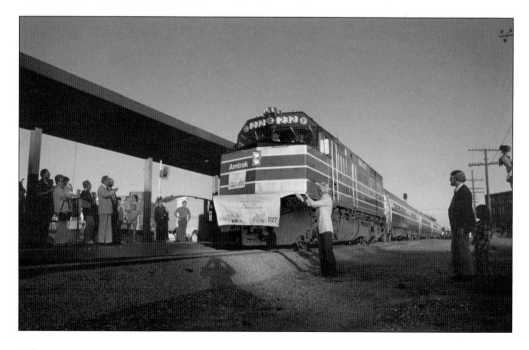

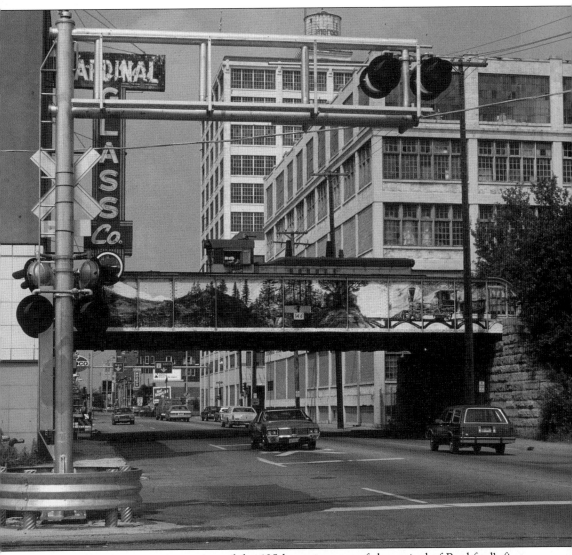

A more permanent commemoration of the 125th anniversary of the arrival of Rockford's first railroad was this ambitious mural that used the south girder of C&NW's South Main Street overpass as a canvas. The giant painting depicts the approach, at right, of the Galena and Chicago Union Pioneer into the unsettled land that became Rockford. Almost hidden by the side girders in this 1981 photograph is the North Western's Rockford switcher. (Photograph by Jerry Pyfer.)

The two winters that followed the warm summer in 1977 were the most brutal in years. Heavy snows followed by blizzard conditions during the winter of 1978–1979 prompted ICG to put snowplows at the head of some trains. Here in January 1979 as photographer Dave Ingles records the event, an eastbound ICG freight pushing a snow-choked wedge plow is about to cross Eleventh Street. (Photograph by Mike Schafer.)

Most of the freight houses of Rockford's railroads outlived the railroad companies themselves. The Milwaukee Road freight house stood on South Main Street, a short distance from the joint Burlington-Milwaukee Road passenger depot. This view was taken during the vicious winter of 1978–1979. The locomotive set at right was probably in town with a snowplow train. Photograph by (Mike Schafer.)

The former C&NW downtown freight house, a portion of which is shown in 1979, along Cedar Street remains standing in 2010 though no longer used for railroad purposes; the C&NW East Rockford freight house on Seventh Street (page 26) also remains. The IC, CB&Q, and Milwaukee Road freight houses have been razed. (Photograph by Jerry Pyfer.)

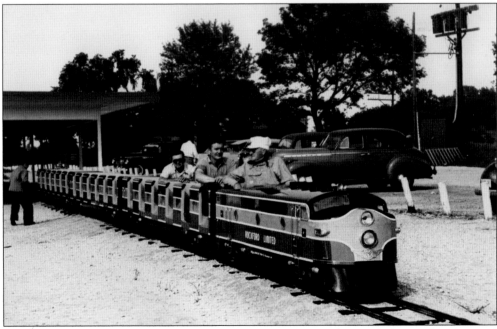

Not to be overlooked was the 1977 loss of another Rockford train: the *Rockford Limited* at Sherwood Park, formerly Kiddieland Park, which closed forever at the end of the 1977 summer season. Built by Miniature Train Company of Rensselaer, Indiana, the *Rockford Limited*, shown shortly after the park opened in 1950, was one of the park's original rides and carried thousands of Rockfordians for more than a quarter century. (BLc.)

In summer 1980, Royal American Shows came to Rockford for an engagement under the auspices of the annual Shrine Circus at Rockford Speedway. Royal American's show train was brought out to the end of the KD Line for layover and loading/unloading. The train is shown "cruising" Madison Street on the old KD Line on its way out of Rockford to its next engagement. (Photograph by Mike Schafer.)

On May 6, 1988, another passenger special operated on the KD Line when Chicago and North Western sent its executive train to Rockford on behalf of Warner Lambert, celebrating the refurbishment of the C&NW line to Rockford as well as the KD Line to Loves Park. The special is shown crossing North Second Street/U.S. Highway 51 as it enters Loves Park en route to Warner Lambert. (Photograph by Jerry Pyfer.)

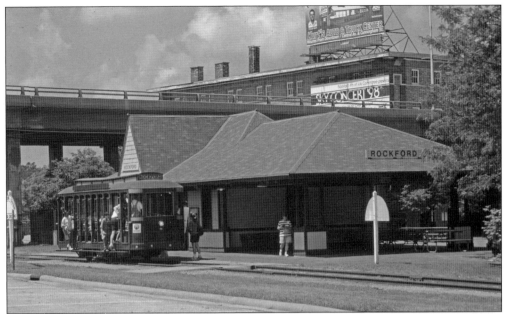

For the first time since the 1930s, scheduled rail passenger service, of sorts, returned to the old KD Line in 1990s in the form of Rockford Park District's trolley operation between this new "old" depot under Jefferson Street (close to the site of the original K&R depot) and Sinnissippi Park. Operations are coordinated so as not to interfere with C&NW (UP) freight operations on the line. (Photograph by Jerry Pyfer.)

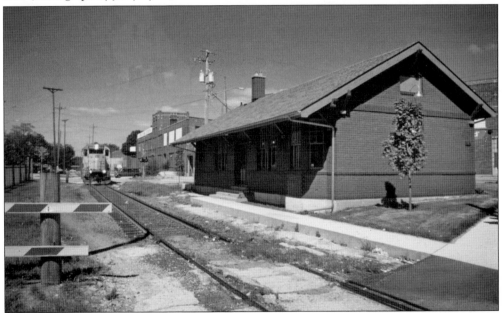

Despite all of the changes that have swept over Rockford's railroads, a few things remain more or less constant. One is the former C&NW East Rockford depot at Seventh Street and Sixth Avenue, which in the late 1990s underwent a renovation that restored much of its original appearance, though its use today is non-railroad. It is shown in September 2000 as the Union Pacific's local heads east for Belvidere. (Photograph by Dale Jacobson.)

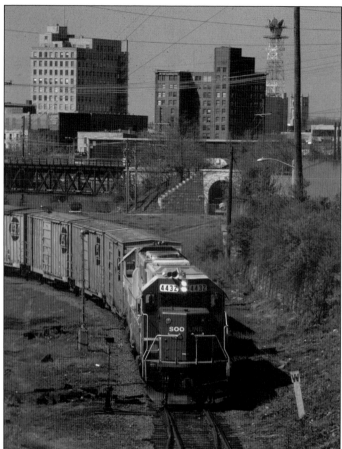

The departure of The Milwaukee Road from Rockford was a sad occasion. The legendary carrier was acquired on January 1, 1986, by the Soo Line Railroad, whose red-and-white diesels power this southbound train out of Rockford to SOO's former Milwaukee Road main line at Davis Junction on April 23, 1986. (Photograph by Jerry Pyfer.)

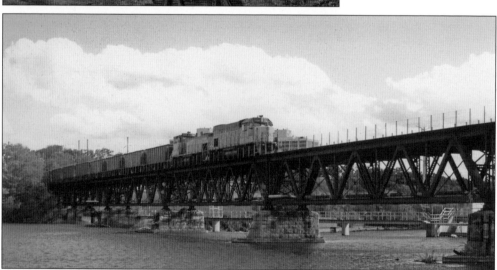

The Chicago and North Western, Rockford's pioneer railroad, was not immune to changes either and finally was merged into America's largest (and just about the oldest) railroad, the Union Pacific, in 1995. Crossing the former C&NW's venerable Rock River bridge, two UP diesels bring a ballast train into Rockford for impending track improvements. (Photograph by Brian Landis.)

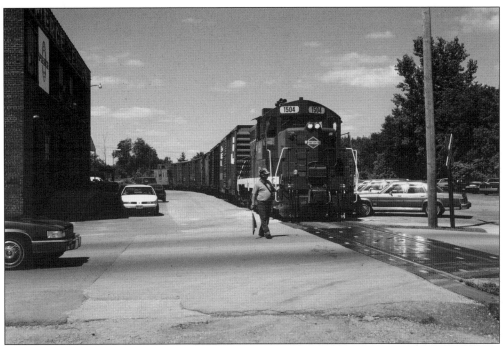

In 1985, Illinois Central Gulf sold off its former IC main line to Iowa to the Chicago, Central, and Pacific, a progressive new company. In the process, the CC&P acquired the old IC diamond herald, replacing "Illinois Central" with "Chicago Central," as evident on the red diesel in this scene above of CC&P's Rockford local about to cross Broadway to switch industries on the Rockford Belt Line on July 31, 1990. A short time later (below), the flagman protects vehicular traffic on Eleventh Street as the switch job backs across the roadway to serve Aetna Plywood. In the background is a famous (some might say infamous) though now-defunct Rockford landmark, the Flying Saucer Motel, which was sandwiched between Milwaukee Road and IC industrial tracks that once blanketed the south side industrial district. (Photograph by Jerry Pyfer.)

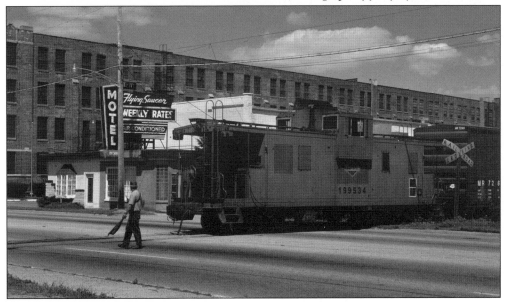

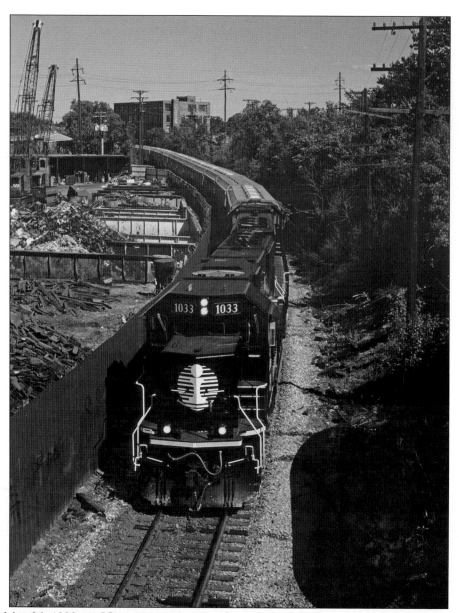

On May 26, 1999, an IC grain train curves through Rockford's southeast side past Testor's Corporation (building in background) and Joseph Behr and Sons (left) before ducking under the Seminary Street overpass. Since the Illinois Central arrived in Rockford for the second time in 1888, it has been the city's principal railroad. In essence, it left again in 1972 with the ICG merger, but in 1996, the IC returned for the third time when it bought the Chicago-to-Iowa main line back from CC&P. The IC itself had returned following a 1988 reorganization involving ICG. On February 11, 1998, the IC was purchased by the Canadian National and has become an integral component of CN's U.S. operations. Interestingly, as this book went to press in 2010, plans were under way for the Illinois Department of Transportation and Amtrak to restore passenger service to Rockford and Dubuque, Iowa, via the old Galena and Chicago Union line between Elgin and Rockford's east side, thence to Dubuque on the CN-IC—certainly another interesting twist to Rockford's railroading history. (Photograph by Jerry Pyfer.)

ABOUT THE
NORTH WESTERN ILLINOIS
CHAPTER—NRHS

Organized by former Rockford residents Jim Boyd and Mike Schafer, the North Western Illinois Chapter of the National Railway Historical Society (www.nwinrhs.com) was chartered in 1969 to research, document, and otherwise preserve the history of railroading in northern Illinois—including Chicago—and southern Wisconsin but especially Rockford-area railroads. The group has operated continuously since 1969 and holds monthly (except June and December) meetings that feature slide presentations and guest speakers. Meetings generally are held on the fourth Saturday of the month at 7:00 p.m. at St. Mark Lutheran Church, north entrance, 675 North Mulford Road, Rockford. NWI publishes a monthly newsletter, the *Northwestern Limited*, providing up-to-date information on area railroad developments and club news. Membership is open to anyone interested in railroading; though most members reside in the Rockford/Chicago area, NWI has members from throughout the United States. For membership information, check the Web site or write to NWI at Post Office Box 5632, Rockford, Illinois 61125-0632.

NWI is an invaluable resource for historians like Brian Landis (above), who served as coauthor to this book. Brian is shown with his restored "speeder" track car, which sits on original Kenosha, Rockford, and Rock Island rails, pulled from beneath Harlem Road when that artery was rebuilt several years ago. (Photograph by Mike Schafer.)

www.arcadiapublishing.com

Discover books about the town where you grew up, the cities where your friends and families live, the town where your parents met, or even that retirement spot you've been dreaming about. Our Web site provides history lovers with exclusive deals, advanced notification about new titles, e-mail alerts of author events, and much more.

MADE IN THE USA

Arcadia Publishing, the leading local history publisher in the United States, is committed to making history accessible and meaningful through publishing books that celebrate and preserve the heritage of America's people and places. Consistent with our mission to preserve history on a local level, this book was printed in South Carolina on American-made paper and manufactured entirely in the United States.

This book carries the accredited Forest Stewardship Council (FSC) label and is printed on 100 percent FSC-certified paper. Products carrying the FSC label are independently certified to assure consumers that they come from forests that are managed to meet the social, economic, and ecological needs of present and future generations.

FSC
Mixed Sources
Product group from well-managed
forests and other controlled sources

Cert no. SW-COC-001530
www.fsc.org
© 1996 Forest Stewardship Council

Find Your Place in History.